CREWKERNE

THROUGH TIME

David Bryant

AMBERLEY PUBLISHING

First published 2013

Amberley Publishing
The Hill, Stroud
Gloucestershire, GL5 4EP

www.amberley-books.com

Copyright © David Bryant, 2013

The right of David Bryant to be identified as the
Author of this work has been asserted in accordance
with the Copyrights, Designs and Patents Act 1988.

ISBN 978 1 4456 1198 3

British Library Cataloguing in Publication Data.
A catalogue record for this book is available from
the British Library.

Typeset in 9.5pt on 12pt Celeste.
Typesetting by Amberley Publishing.
Printed in the UK.

Introduction

Crewkerne prospered from the sheep trade in medieval times, and was able to build the wonderful church, seen on the following page, as we have it today, with its Perpendicular architecture and a lovely statue of St Bartholomew over the south porch. The church is built in Ham stone.

Crewkerne is a market town in Somerset. Its population in 2001 was 6,728. Located on the A30 between Chard and Yeovil, which was the main highway back in 1950s between London and Penzance. These days, the A303 has taken its place.

In the 1950s early closing was Thursday afternoon, but these days to the author it feels like shops never seem to want to close. There are three supermarkets: Lidl, Co-op and Waitrose, but back in the 1950s you would never have thought the High Street would change. This has occurred not only in our town but every town in the country, with charity shops and estate agents' replacing the old, small shops, which in many places have now disappeared. Will they ever come back?

On 2 May there was great excitement in the town with great crowds of people and hundreds of schoolchildren lining the Market Street and around the Square, as Her Majesty the Queen and Prince Phillip arrived as part of the Queen's Diamond Jubilee Tour, and were greeted by the Lord-Lieutenant, Lady Gass, who in turn presented the mayor, Councillor Neil Sturivant, to Her Majesty. Afterwards they went upstairs in the town hall to see exhibits put on by groups in the town.

In the tenth century there was a Saxon mint in Crewkerne. The town was noted for its goldsmiths and the wool and flax industry which led to the rebuilding of the parish church on a grand scale in fifteenth and sixteenth century.

Samuel Sparks' factory was located at Viney Bridge in South Street in 1789. Later this became Arthur Hart & Son webbing factory which, 200 years on, manufactured parachute harness webbing for the space shuttle *Columbia*. Crewkerne gained gas lighting in 1837, and in 1894 formed an Urban District Council. This boom period saw the construction of many of the buildings that now characterise the town centre – shops, banks and inns, all in the Georgian and Regency styles, which are as attractive to modern eyes as they were during their day.

In 2013 Industry Cronite Castings, Parker Hydraulics Ltd, Tods Aerospace, Quantock Joinery Systems Ltd, Rotalink, Euro Quartz Ltd, Singletons Engineering, Ves Precision Ltd, Bobs Tyres, All Glass, Lotus & Cortnia Spares and many more were resident in the town. Crewkerne has also taken a major step forward with the granting of outline planning permission for 525 houses to be built east of Crewkerne, as well as office or factory space, a primary school, community facilities, playing fields, parkland, and also a link road connecting the A30 to Station Hill. It is being built by Taylor Wimpey and will be just what Crewkerne needs – a little uplift to the town.

I would like to thank all the people who lent me the photographs to make this book possible.

David Bryant

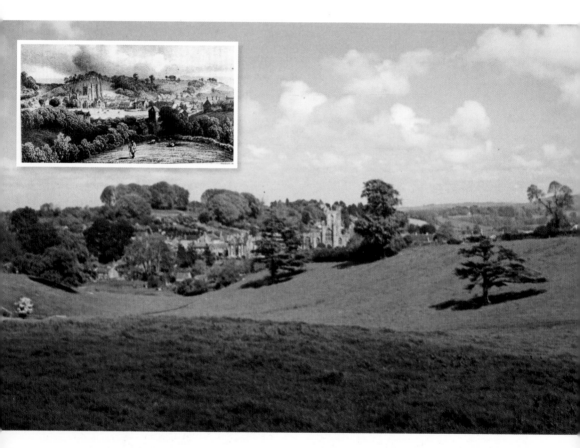

St Bartholomew's Church
Two images showing St Bartholomew's church, Crewkerne, taken from the *Book of the Axe*. I would have thought the town grew around the church in those days. In the sixteenth century the church was rebuilt. The main picture was taken from Lower Bincombe looking towards the church.

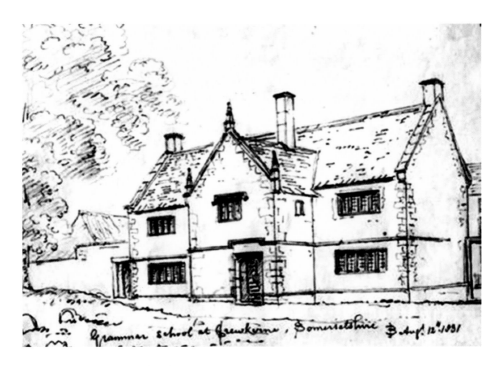

Grammar school at Crewkerne, Somersetshire B Aug 12th 1831

Crewkerne Grammar School, 1831

The Grammar School had some famous scholars. Thomas Hardy was taught at the school. It was founded by John De Combe, formerly vicar of Crewkerne, in 1499. It then moved to Mount Pleasant in 1882. In the 1950s the magistrates' court was held here. The building has been the church hall for many years. Below, the church fête in 2008, with some stalls outside the hall.

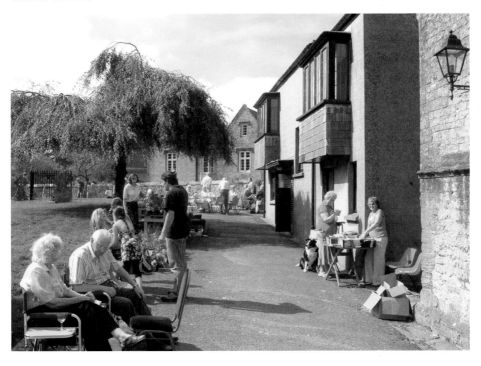

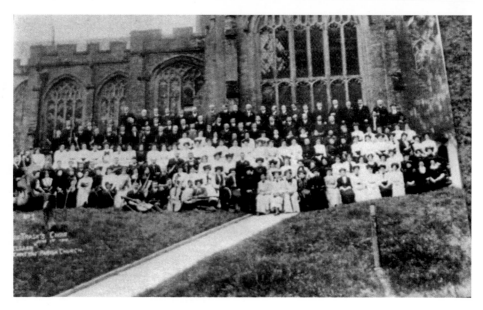

The Choir

Above can be seen Mrs Trask's choir of 1901. The image below shows the 2011 St Bartholomew's church choir, with choirmaster John Dale and the organist.

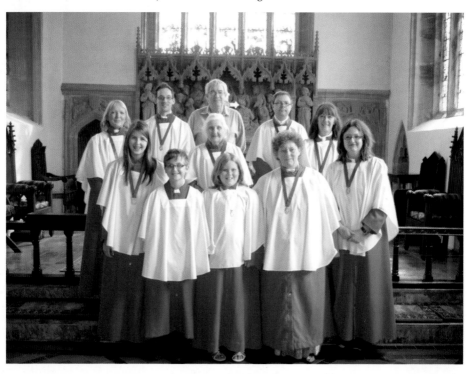

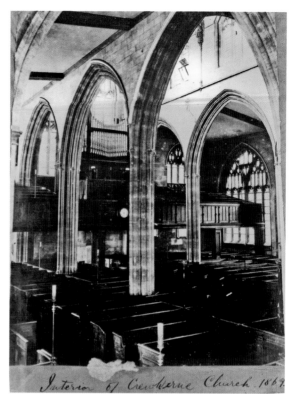

Interior of Crewkerne Church 1869.

The Organ

In 1869 the organ was situated at the back of the church near the west door with the galleries above. In the 1950s these galleries would be filled with grammar school boys, with schoolchildren from Bincombe School and St Martin's also in the congregation. The galleries are not used today.

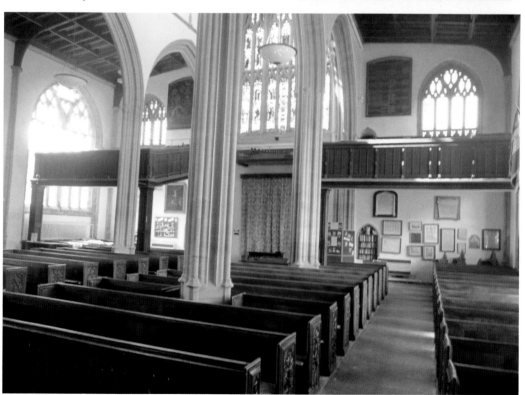

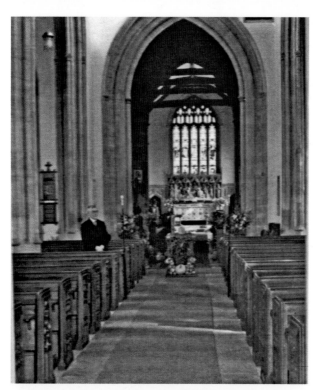

Festivals
Left, Harvest Festival in 1948 when Mr Eveleigh was the churchwarden. In 2009 we had our first Christmas tree festival. This has been a great event each Christmas since. Vivienne Stuckey organises it with the help of other people from the church.

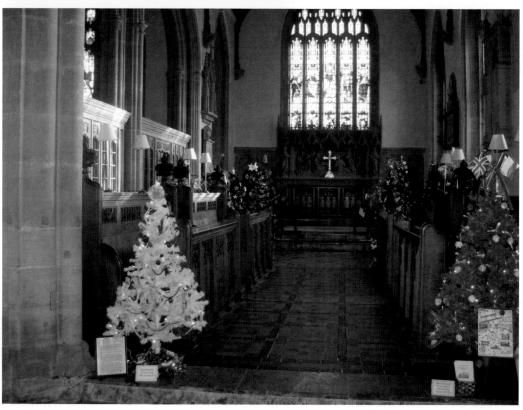

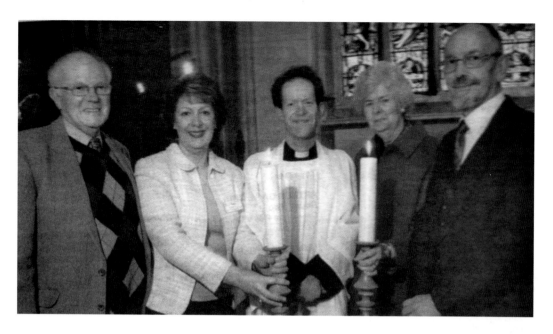

Events

Above, an evening song service in aid of St Margaret's Hospice, 2007. Pictured are Sidesman David Bryant; Sue Scott, representing the Hospice; Curate Alan Ellacott; Churchwarden Dorothy Tozer and Sideman Phillip Martin. Below, the flower festival in 2006, put on by the Ile Valley Flower Club.

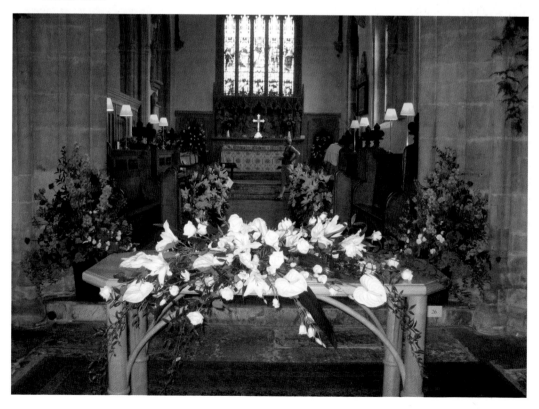

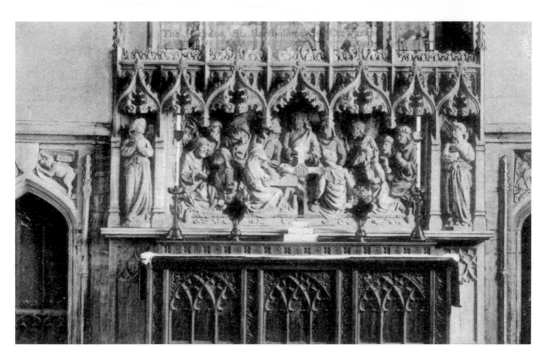

The Altar

Above, the altar, seen in 1900, backed by a Ham stone carving of the Last Supper. Below, the harvest festival, 7 October 2012. Food was collected in tins and was given to Women's Refuge.

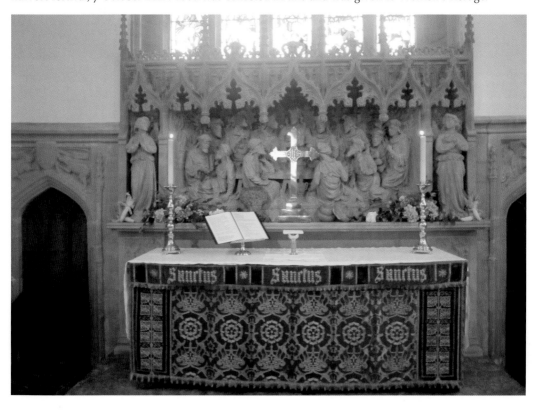

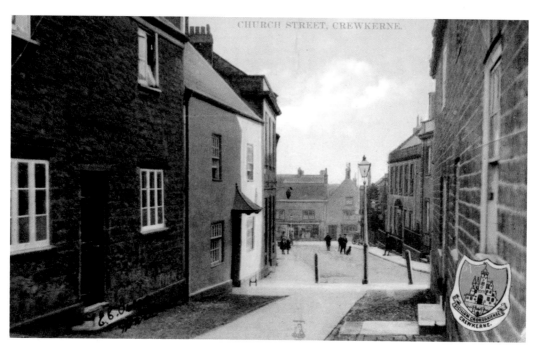

Church Street

Church Street, pictured around 1900, when gaslights were common, looking down from near the church steps. Below we see what it looks like today. The building on the right in Church Street used to be town council's offices before they moved to Victoria Hall in 1995.

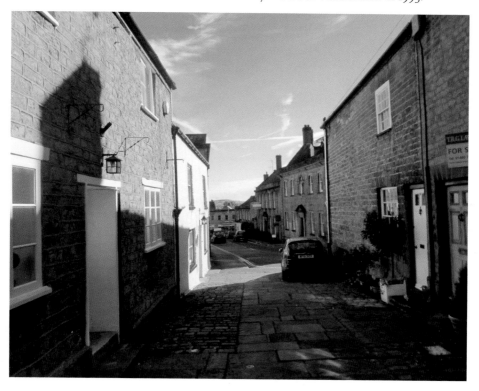

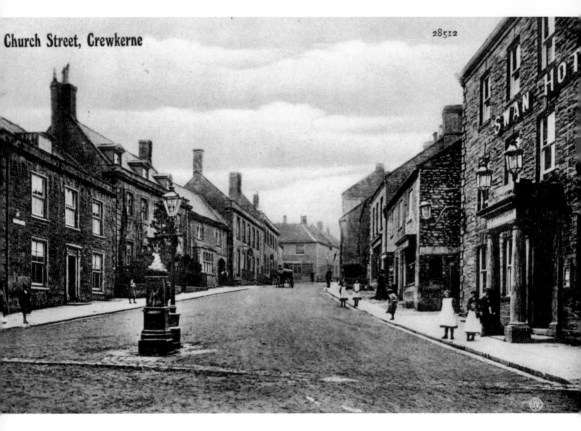

Church Street, Crewkerne

28512

SWAN HOTEL

Church Street

Above, a view from 1880 looking up Church Street with the Swan Hotel on right. A gaslight and water trough can be seen in centre of the road. The Swan Hotel is still there, with a small garden in the centre of the road. The road is the A30 from Chard.

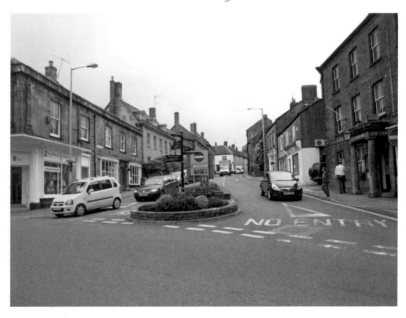

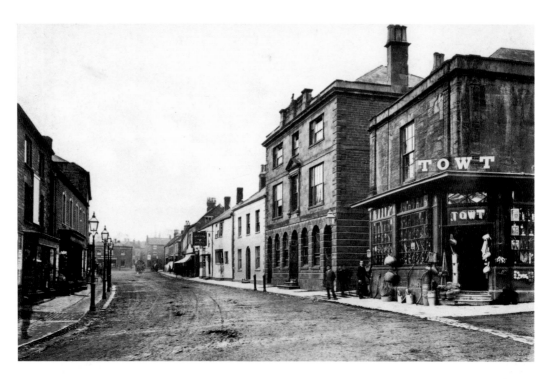

Market Street

Above can be seen Towt ironmongers in 1871, next to Stuckeys Bank. In those days it was called Sheep Market Street. In the 1900s this was changed to Market Street. Below, the corner of Market Street now houses the Children's Society, next to the Westminster Bank.

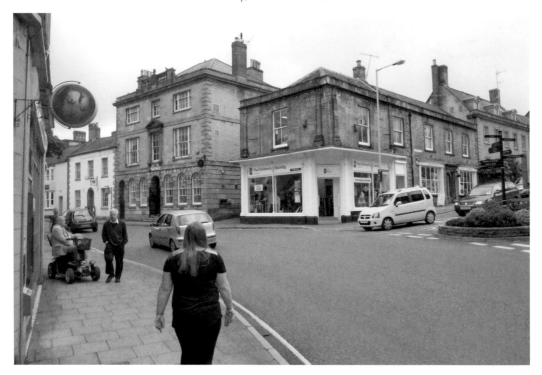

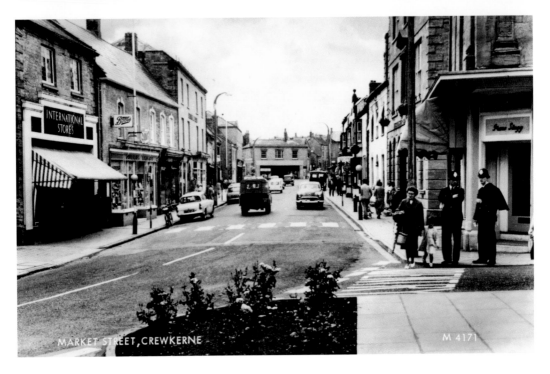

Market Street
Looking up Market Street and Irene Stagg is now located where Towt used to be. International Stores can be found opposite, with Boots the chemist next on. Boots the chemist moved to the opposite side in the late 1980s. Below, a view of the Boxing Day Seavington Hunt in 2005.

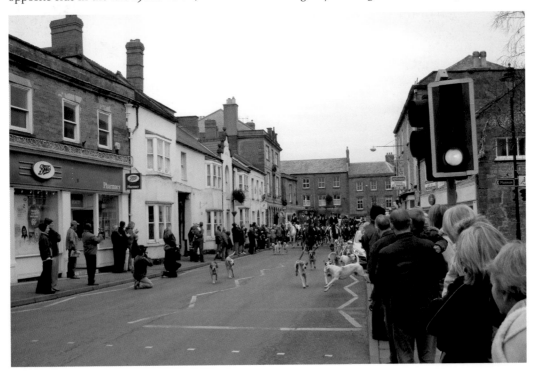

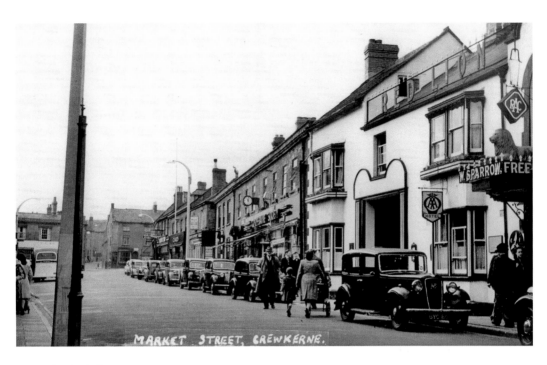

MARKET STREET, CREWKERNE.

The Red Lion

In 1932 the proprietor of the Red Lion Hotel was W. C. Sparrow. The Red Lion was a first-class family hotel, with dainty teas served on the garden roof. Today it is Bilby's Café, also in Ilminster, with housing around the back.

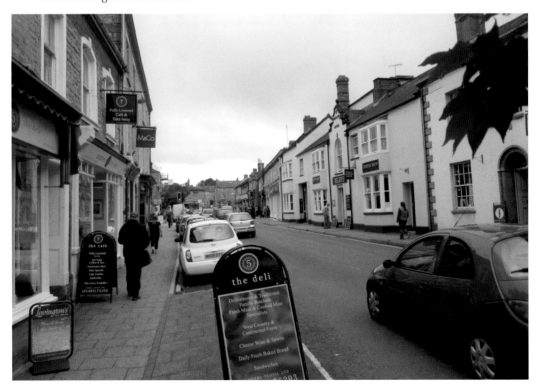

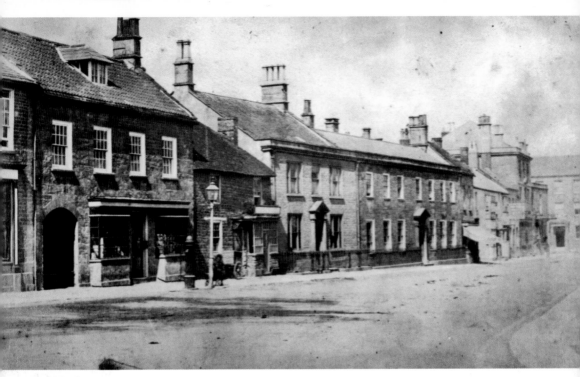

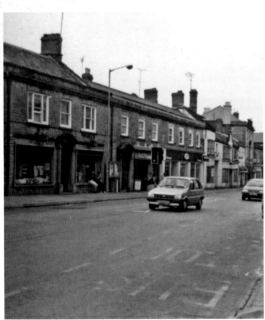

Crewkerne & District Industrial & Co-operative Society
Chard's shoe shop in the Market Street in 1890. Where the houses are can be seen what became the Crewkerne & District Industrial & Co-operative Society Ltd, opened in 1900 and closed in the late 1980s, becoming Boots the chemist, Dillons and the Fabric Shop.

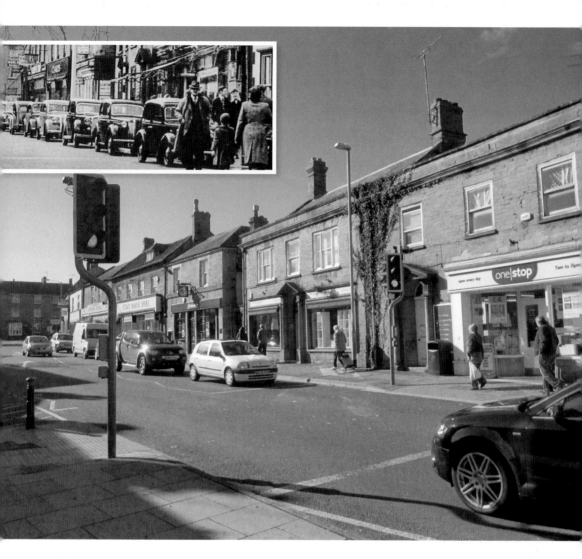

Market Street

Market Street showing where the Co-op was in the 1950s, a lovely shop with a grocer department and Dick Pitman, butcher's. The clothes and furniture department closed in the 1980s. Edward Wadsworth was the manager, and the family lived over the shop. Boots the chemist and Dillons took it over at a later date, followed by One Stop and Brain Wave Charity Shop.

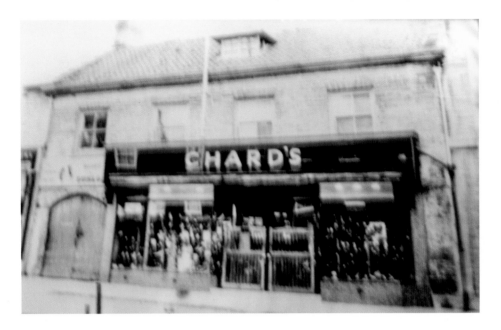

Chard's

T. N. Chard started the business and was followed by his sons, Fred and Herbert. They were agents for Brevit, Lotus, Kiltie, Novic and Clarks shoes. Their shops could be found in Chard, Beaminster, Ilminster, Street, Langport, Martock, South Petherton, Somerton, Wells and Yeovil. Michael and Peter, Fred and Herbert's sons, retired in 1987. Stuart Marsh rented the shop before it closed in September 2012. Below, the carnival on 21 October 2005.

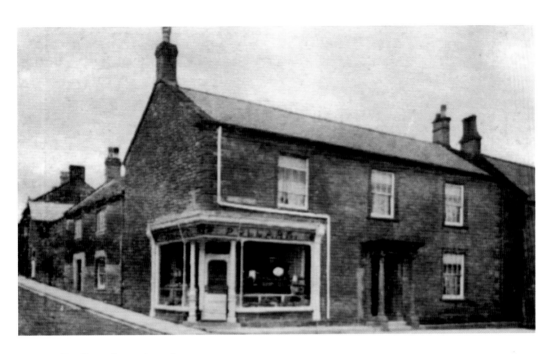

Pollard's and Woolworths

Above, Edward Pollard, pastry cook's and confectioner's, seen in 1925. Pollard's were awarded prizes for Hovis bread and currant bread. They closed in the late 1950s, and were followed by Woolworths.

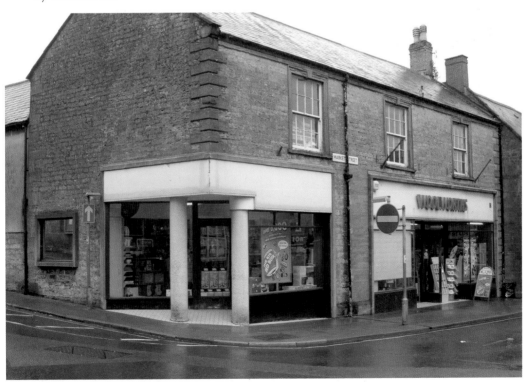

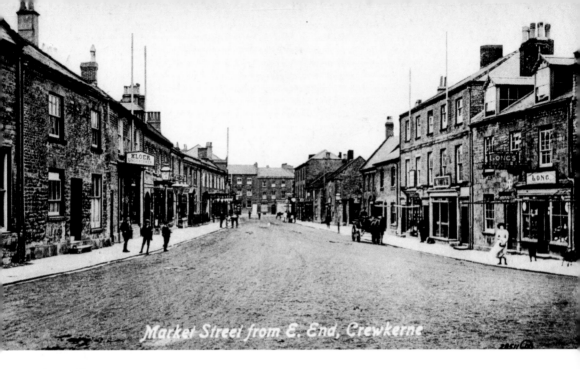

Market Street from E. End, Crewkerne

Henry Kloer

Looking down Market Street with Henry Kloer's shop on the left, which had been selling furniture, carpets, beds and bedding since around 1889. In the 1950s this was the main road from London to Penzance.

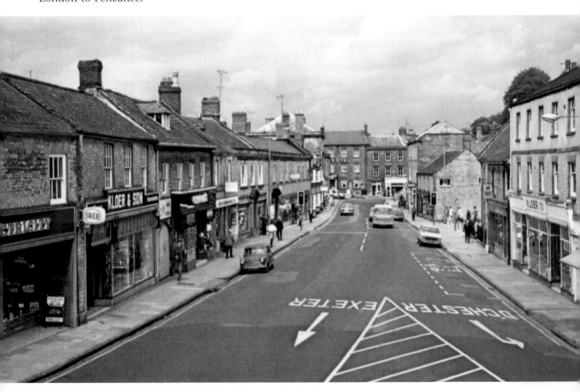

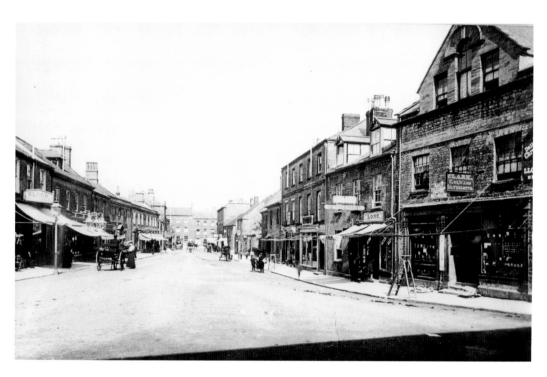

Clark, Gold & Silversmith
Seen in 1900, Clark, Gold & Silversmith is on the right next to Long's Restaurant. Opposite can be seen H. Kloer's shop by the horse cart on the left. In 2013, shops today include Stage 4 Kidz, Barrett's Butchers and the Crewkerne Antiques Centre.

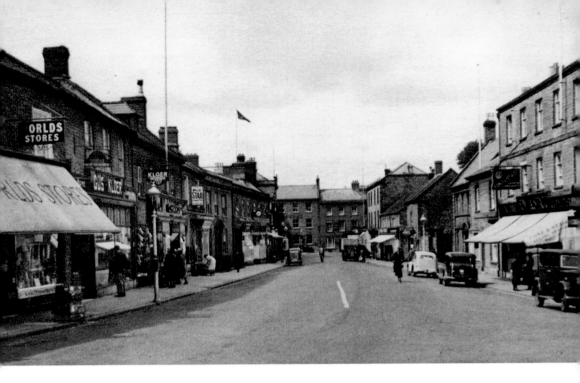

World Stores

World Stores was a grocer's shop in 1950s and 1960s. It was taken over by Key Markets in the 1970s, who moved to Falkland Square when it closed in the late 1970s. Below, Market Street in the winter of 1963.

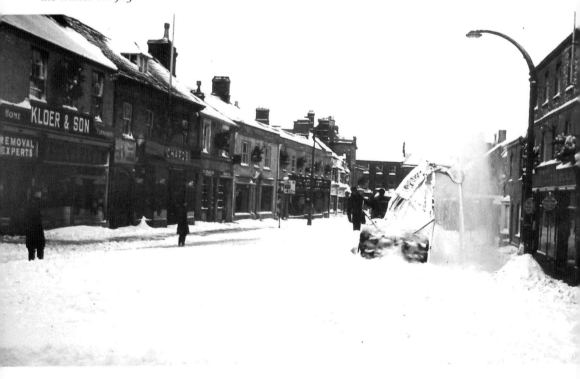

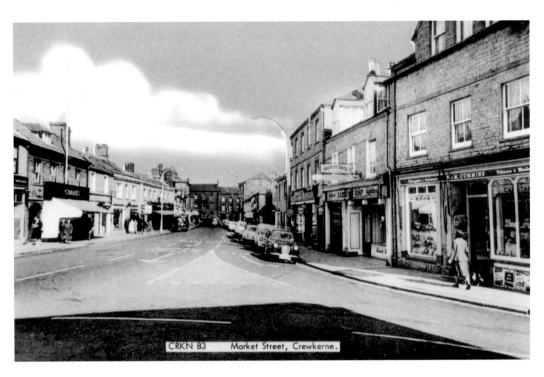

CRKN 83 Market Street, Crewkerne.

Newsagents

Below, Market Street in 1960, with Wright's newsagent's on the left and Rainbow Café next door. Later came Cummings newsagent's, as seen in the postcard above.

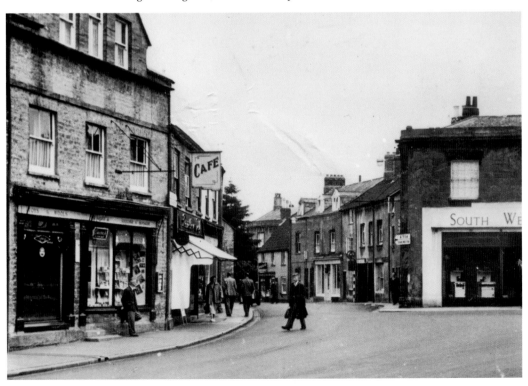

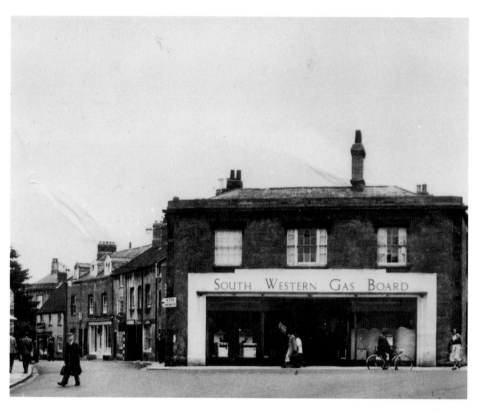

Gas

In 1950 the South Western Gas Board sold gas fires and cookers as well as providing other services. You paid your gas bills here. Before that it was Burton's grocer's shop in around 1930. In 2012 it is Gresham's second-hand bookshop.

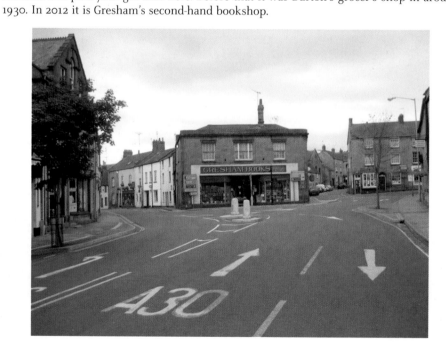

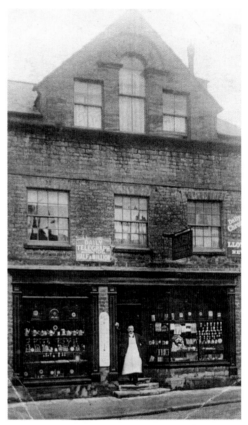

Gold & Silversmith

In 1900, W. Clark stands outside his shop Gold & Silversmith, which also provided books and stationery. There is advertising for the *Daily Telegraph* above the shop window. In 2012 Prelude Sports can be seen.

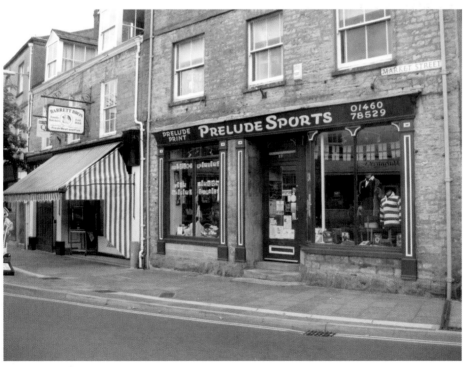

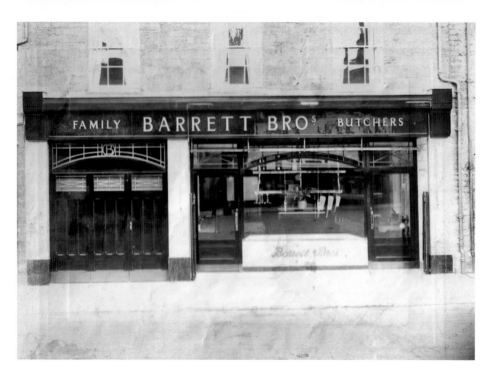

Barrett Bros

Barrett Bros moved here in 1929, from their former premises in South Street. George Durrant was the proprietor here in the 1950s and 1960s, and John While arrived in 1980s. The view from 2010 shows Pollocks with a hog roast at the lighting ceremony just before Christmas.

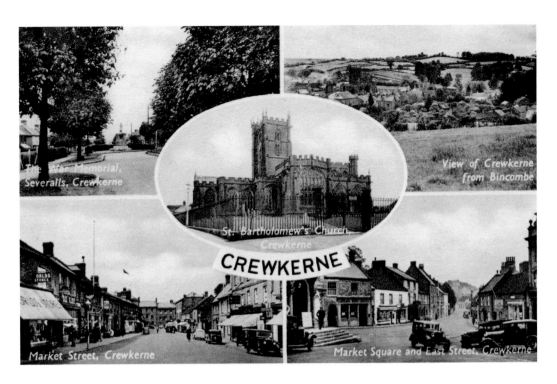

Fone & Stagg

Seen in 1932, Fone & Stagg, ladies and gentlemen's tailors and complete outfitters, is located towards the bottom left of the image. With a phone number of 54 Crewkerne, it was established in 1850. Also seen are Vanessa's Hairdresser and the Black Swan Dental Spa.

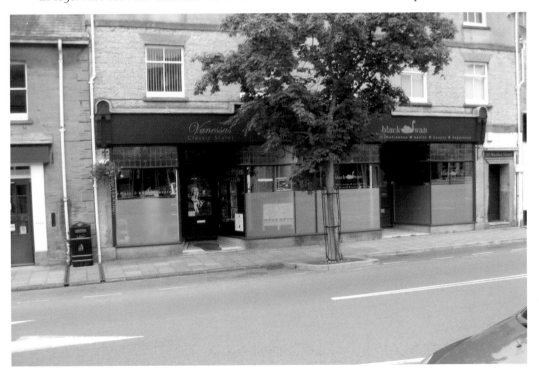

St Martin's School
St Martin's school in the 1960s. The headmaster was Captain Swingler. The school moved to Abbey Street in the 1960s owing to the Falkland Square development. Today Poole & Co. Solicitors occupy the building.

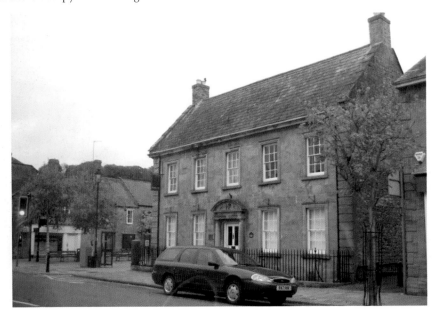

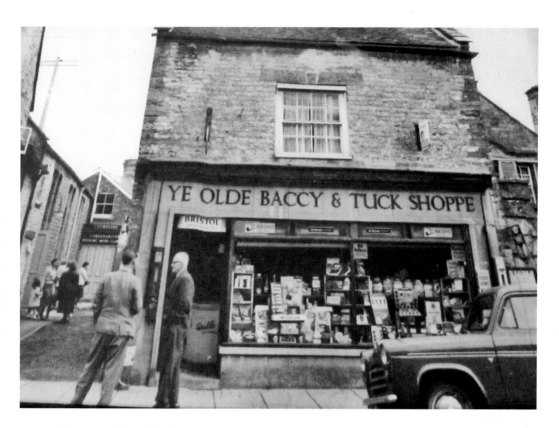

Tobacco and Pram Racing

In 1950 this was Ye Olde Baccy & Tuck Shoppe, selling snuff, cigarettes and pipe tobacco. The Conservative Club was up the passage on left. Below, the annual Crewkerne pram race, Boxing Day 1960.

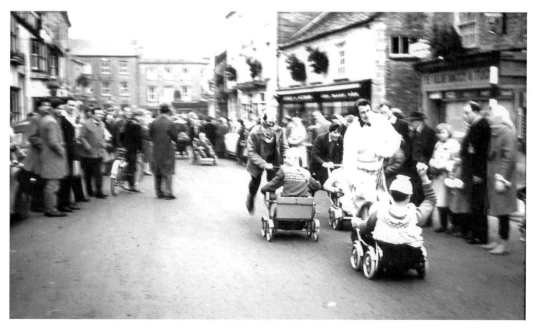

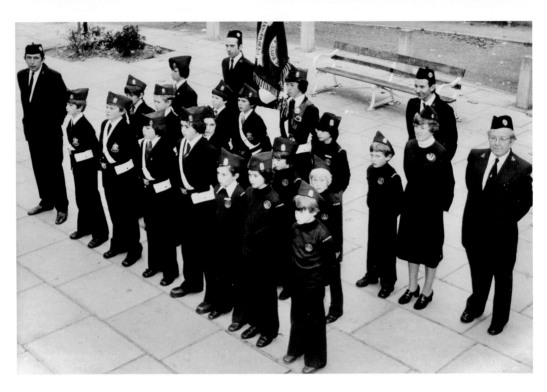

Crewkerne Boys' Brigade
Above, Crewkerne Boys' Brigade in Falkland Square in 1978, with Captain Norman Pinney on the left. Peter, Michael and Carol Chard and contingent, and Revd Sowerbutts of Baptist chapel, are on the right. Below, Falkland Square in 2012.

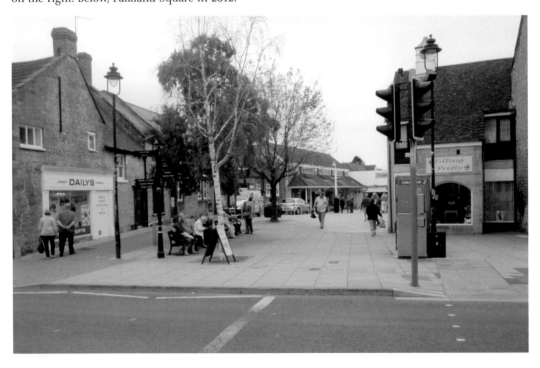

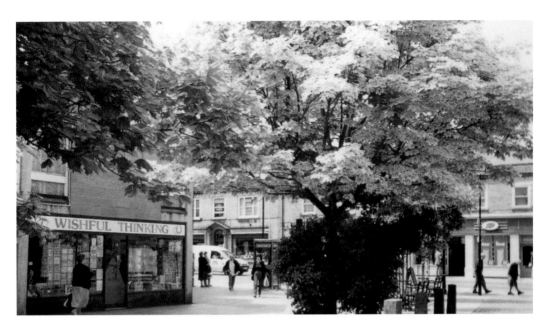

Wishful Thinking

Seen in 1980, the Wishful Thinking card shop. Boots the chemist can be seen on the right on the opposite side of the road. Below can be seen Stokes, Pets Centre and Strawberry Fayre Café. Stokes closed down in 2010. Pictured are Mary Chant and the late Doug Leach.

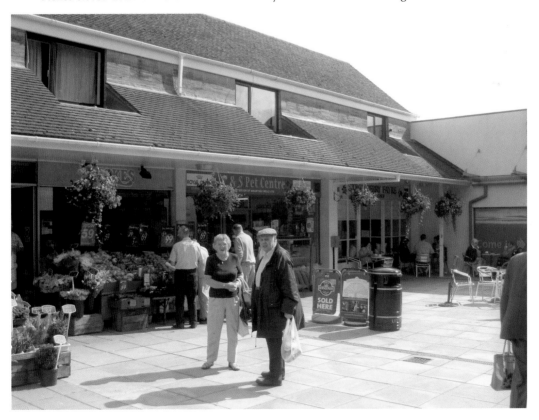

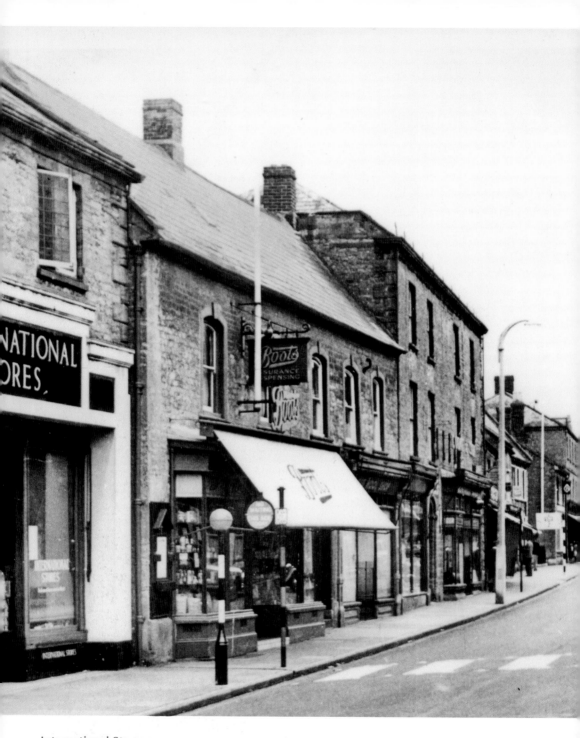

International Stores

Pictured in 1932 are four shops up from International Stores. These included Doney & Cooke, Crewkerne & Ilminster ironmongers, glass and china merchants, oil cooking stoves, drawing and dining, grates, tools and wares. They closed in 2005. In 2012 this is M&Co. men's and ladies' clothes and children's wear, with Daily's on the corner.

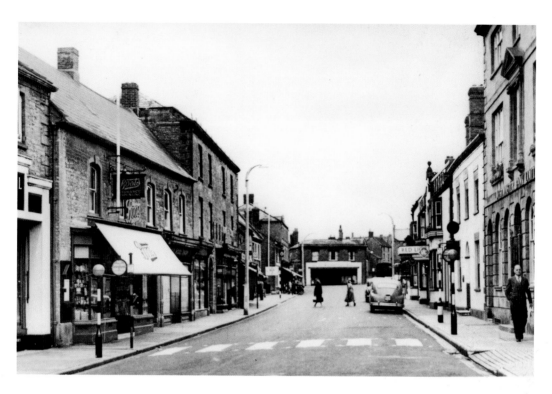

Boots

Seen in 1960, Boots the chemist, the Wool Shop, and Cooke & Son. The pedestrian crossing situated here in those years was moved when the Falkland Square was built. Below, inside Boots the chemist in 1964, Jennifer Childs and Susan Fry, *née* Hines.

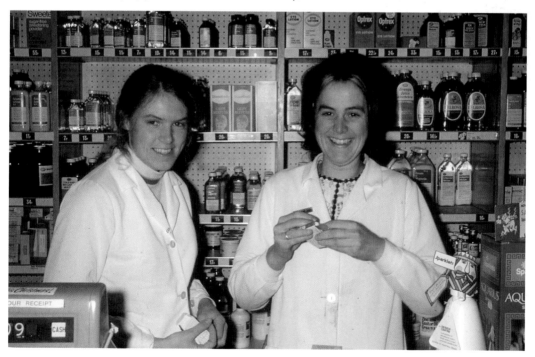

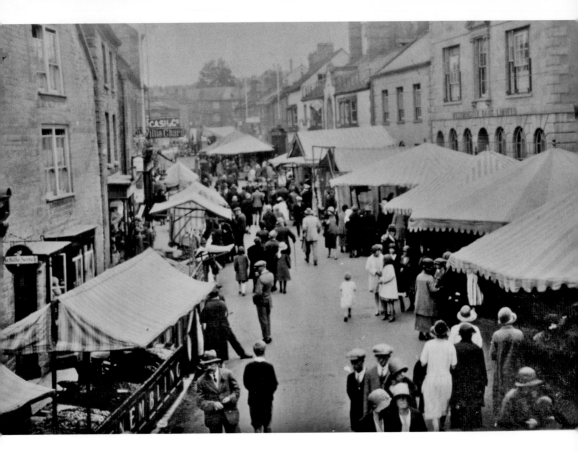

St Bartholomew's Fair

St Bartholomew's Fair, 4/5 September 1920. The fair occurs annually, but the date has been changed to the nearest Friday and Saturday. It goes back to 1275. Below, in 2010, the throngs of people have thinned out in recent years.

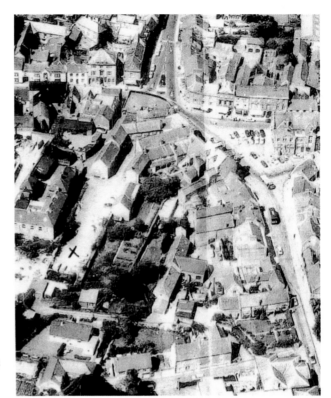

Aerial View

Right, an aerial view of Crewkerne. The X marks where the George Hotel car park was from the 1940s to the late 1990s, when the George Centre was built. Lots of shops, including Lidl and Stoodley & Son Undertakers, can be seen towards the back of the car park in the modern view below.

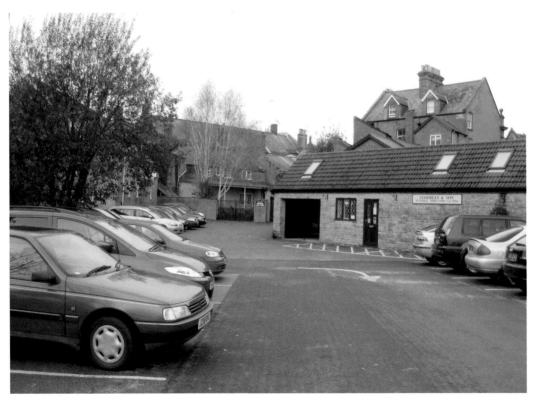

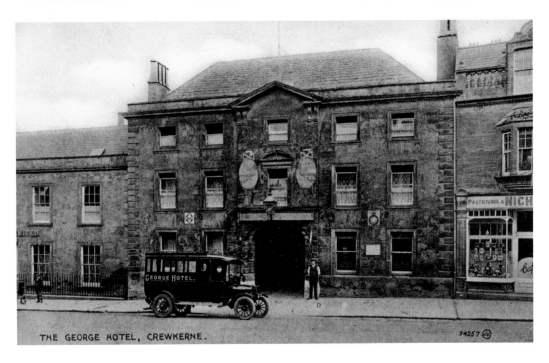

THE GEORGE HOTEL, CREWKERNE.

The George Hotel

The George Hotel, seen in 1920, next door to Nicholas' bakery shop. In 1927 it changed hands when W. T. Bryant bought it from Mr Nicholas. The bakery was in South Street. Later, in the 1950s, it became Dorset Farmers seed shop. Below, the George Hotel in 2009.

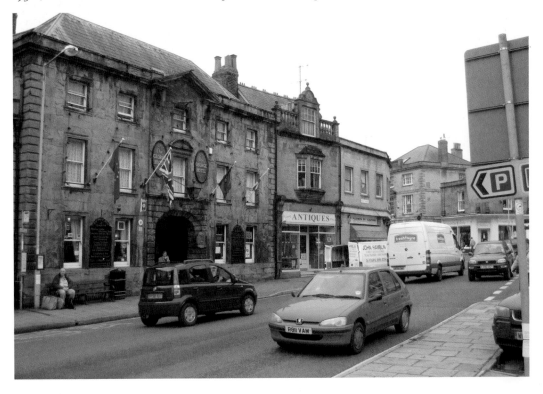

Robert Gutsell

Robert Gutsell, London House Draper, is seen to the right in 1935. This gents and juvenile outfitters, agents for Wolsey hosiery and underwear, was demolished in 1961 to make way for London House, seen below in 2012.

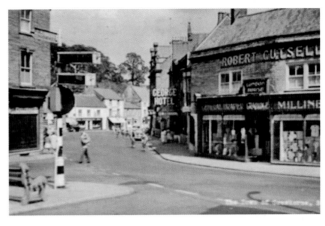

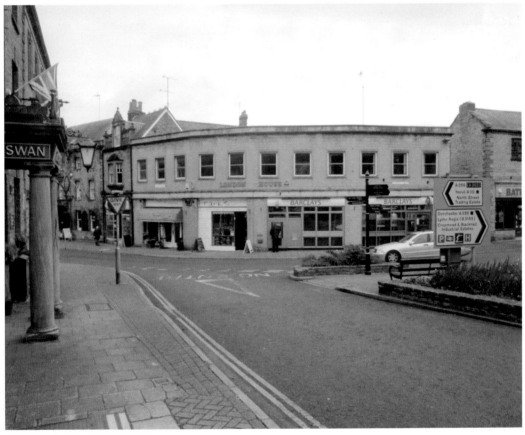

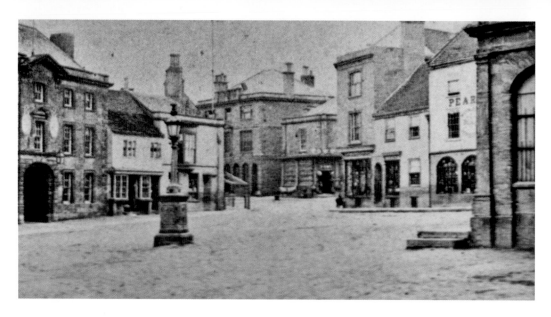

The Market Place

The Market Place, seen in 1869, with John Partridge's draper's shop on the right corner, next to Joseph Pearce, chemist, druggist and grocer. Below, crowds of people awaiting the arrival of Her Majesty Queen and Prince Phillip on the Diamond Jubilee tour, 2 May 2012.

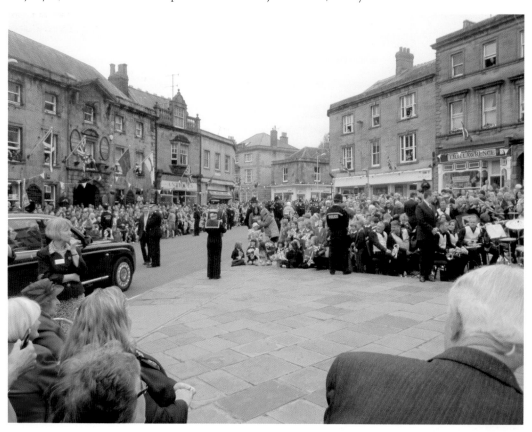

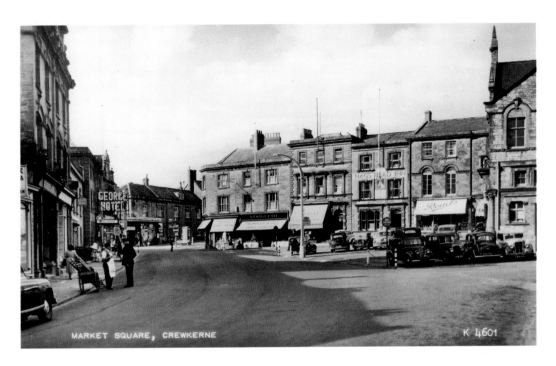

Market Square

Market Square, seen above in 1950. Nicholas & Gee, high-class grocer, provision merchant and coffee specialist can be seen on corner. Next on is Frances' Hairdresser and the Nag's Head. Below, children waiting for the Tour of Britain in 2010.

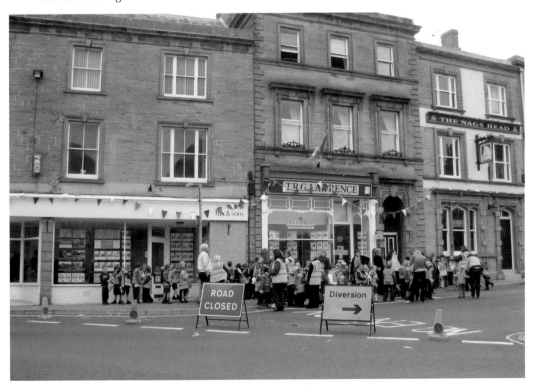

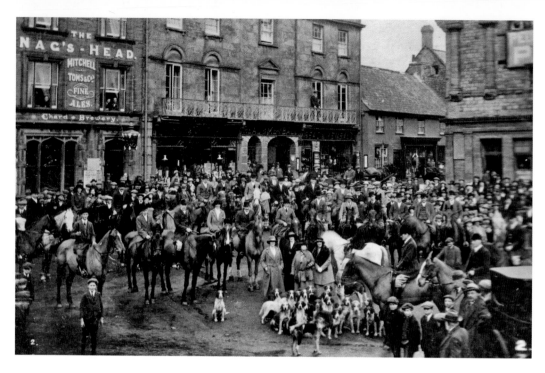

The Seavington Hunt

Above, the 1923 Seavington Hunt outside the Nag's Head Inn, Reads & Kemble and Thompson Edmonds' grocer's shops. In 2010 these have been replaced by Bengal Fusion Indian Cuisine and T. R. G. Lawrence, estate agents.

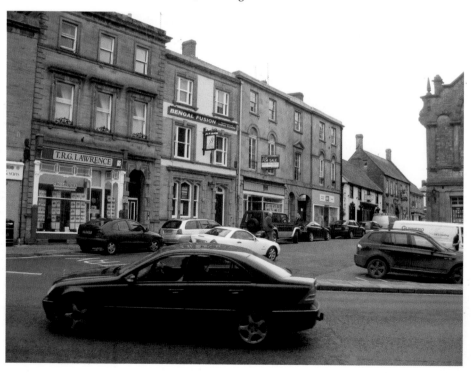

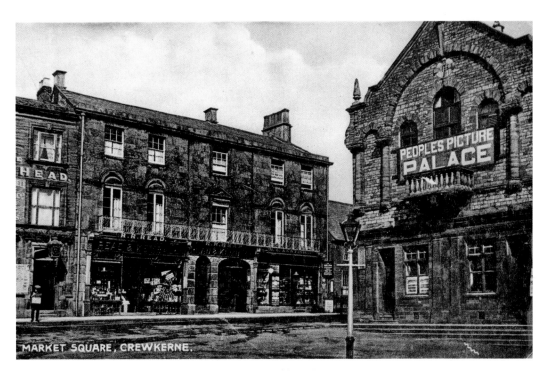

People's Picture Palace
The People's Picture Palace in 1860. It was located here for many years before moving to West Street. Below, seen in 1970 are Victoria Hall, B. Prest Electrical and Tea Cake Café (proprietor Mrs Maitland).

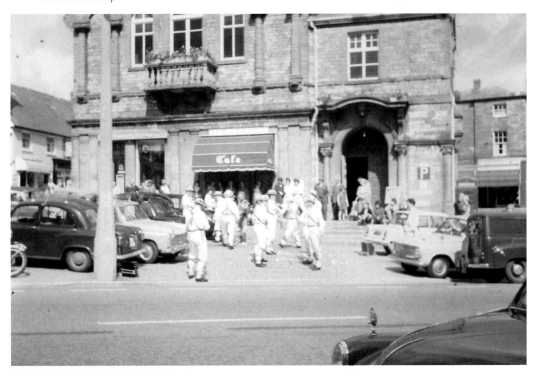

Two Queens

Above, a picture from the steps of Victoria Hall of Ralph Reader and the British Legion carnival queen in 1946. Ralph Reader was born in Crewkerne and lived at Court Barton. He did many shows here with the Gang Show in the 1950s. Below, on 2 May 2012, the Diamond Jubilee tour of Her Majesty the Queen. Outside the town hall, Prince Phillip, the Queen and Lady Gass, along with Mayor Neil Sturtivant, visit the displays from different organisations of the town.

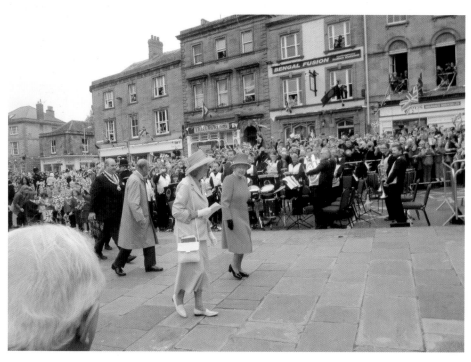

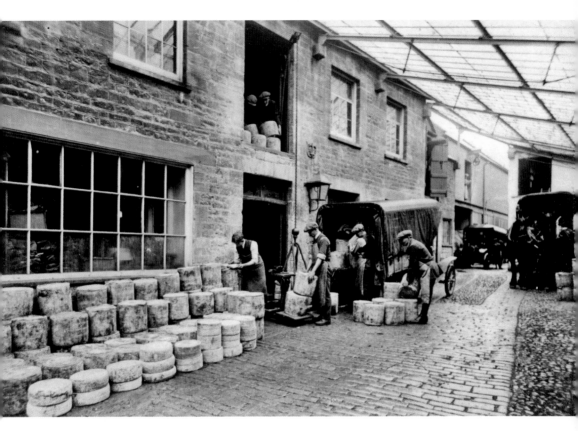

Thompson Edmonds

Thompson Edmonds' cheese store in the 1930s. They also had a shop were Oscar's wine bar is today, on the left-hand side of the Victoria Mews.

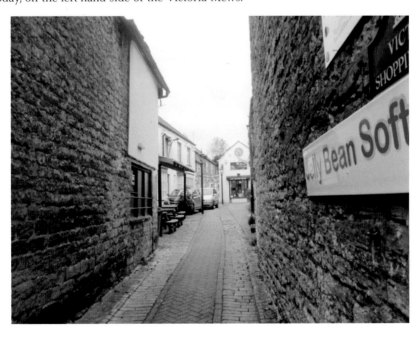

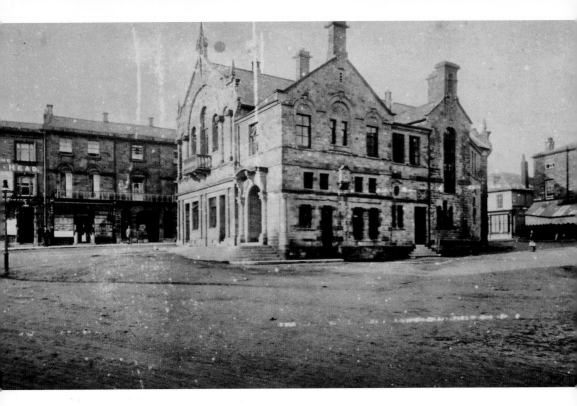

Hancocks

In 1925 Hancocks was a popular shopping centre for ladies and children. Overcoats for men and boys were also available from here. In 2012 it was taken over by Stokes Partners Solicitors, Golden River Chinese restaurant and Rodford's florist.

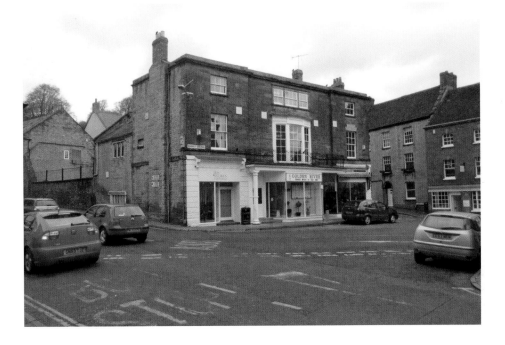

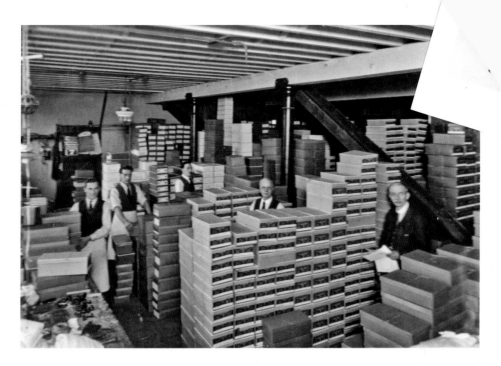

West Somerset & Devon Shirt Manufacturing Company, 1930

In the 1940s the West Somerset & Devon Shirt Manufacturing Company merged with their factory in Abbey Street. This was later taken over by Pithers, a furniture store, but was burnt down in the 1960s. After this it became a second-hand bookshop located behind Hancocks. As seen in the photograph from 2012, it is now a car park for Stokes Partners Solicitors and Pithers Court.

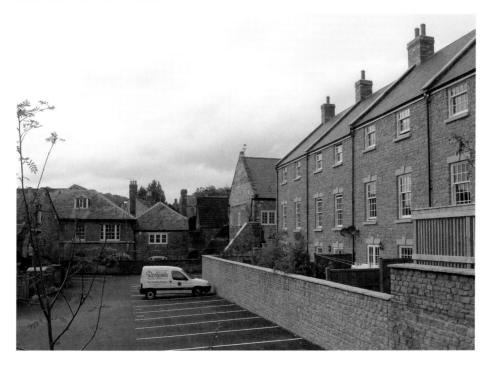

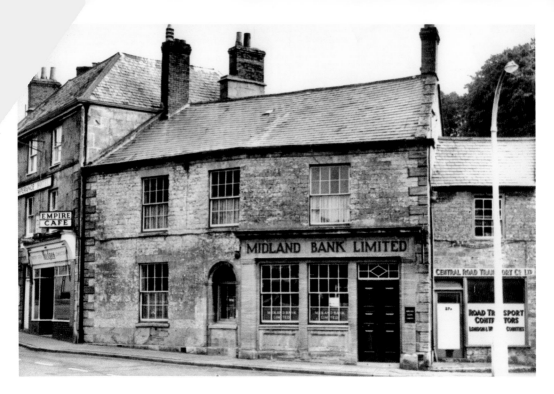

Roy Hodges' Baker's Shop and Empire Café

This shop and café moved here in 1929 from Lye Water. In 1950 it was occupied by Midland Bank Ltd; next door was the Central Road Transport Company. Mrs B's Sandwich Bar and HSBC Bank now stand in their place, as seen below in the photograph from 2011.

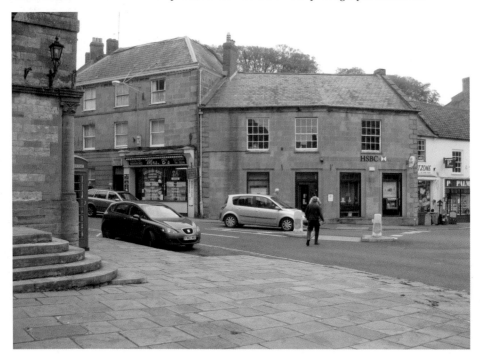

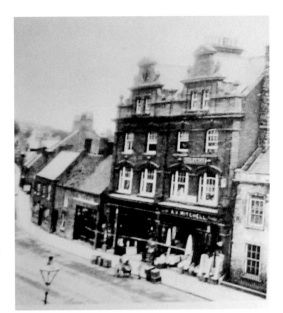

Queen Anne Building

This 1931 photograph shows the Queen Anne building with the clock on the left at the top. A. V. Mitchell, linen and draper's shop, was on the right. The shop on the left belonged to Albert Stoodley, cabinetmaker and general house furnisher. In 2012, these premises were home to Barons, No. 31 Hair and Beauty, and McKinlays.

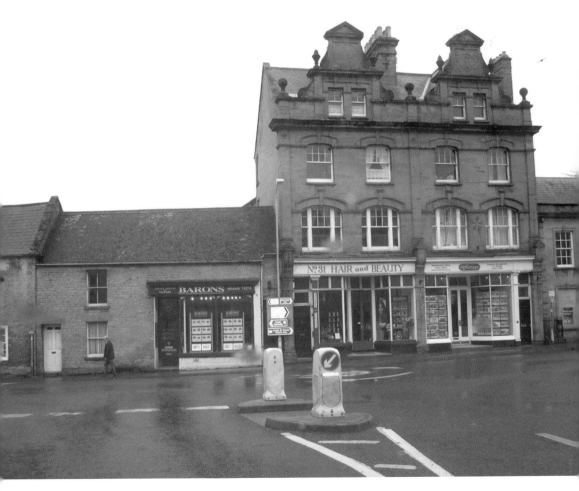

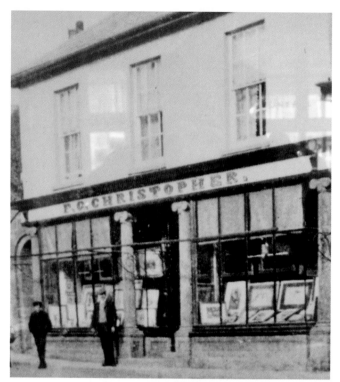

Abbey Street

Left, pictured in 1861, the shop of Fredrick Christopher, photographer and artist. In 1800 Abbey Street was called Carter Street. The shop sold picture frames of every description. In 1930 the shop was moved to No. 1 North Street, run by his daughter Eva. In later years, the shop was a jeweller's, run by W. Clark, Adams & S. Parker. Doreen Chapman took over in the 1960s, when it was turned into a ladies' fashion shop. In 2007, it became Stokes Partners Solicitors but in 2009 changed to A. J. Wakely & Sons, independent family funeral directors, which it remains today.

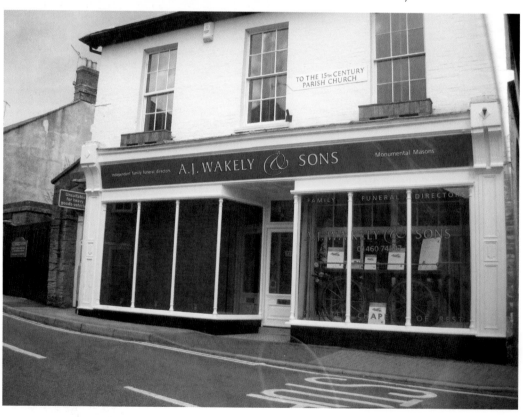

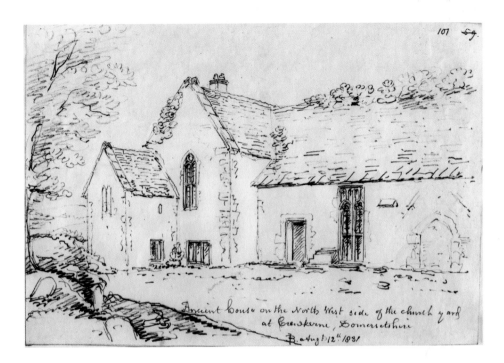

Ancient house on the North West side of the church yard at Crewkerne, Somersetshire
B. Aug^t 12th 1831

The Abbey

In 1700 this was the priest's house. It was rebuilt in 1831, and some additional windows were incorporated into the building. In 1872 John Hussey, who was a solicitor in the town, lived here. The Abbey was a residential house in 1890s, soon after becoming a nursing home run by Mr Lawton. Part of the building was used as a doctors' surgery in the 1940s, but this closed in 1983. Dr Cheyne, Dr Thompson, Dr Hodge and Dr Woodley practised here.

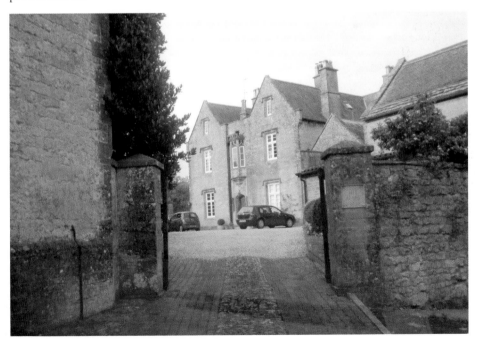

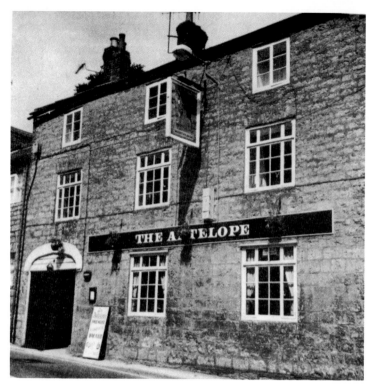

The Antelope
In 1931 Walter Pattemore was the licensee; when his haulage business started he would back his lorry under the arch. He brought his family to the area before moving to Rose Lane in the 1940s. His son Bill bought Newbury's slaugherhouse in Hermitage Street and later started Pattemore's Transport. Syd Pattemore closed the business in 1983. In 2007 the public house became flats, as seen below.

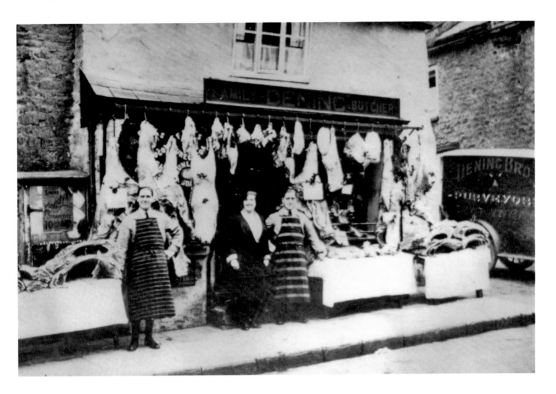

Dening Family Butchers

In this photograph, dating from 1912, butcher James Dening stands with his son and daughter, Minnie and Jim Dening, outside his shop on North Street. By the 1940s Jim was running the shop. It closed in the 1970s, becoming Graham Elswood cleaning suppliers in 1972, before this business relocated to Blacknell Lane.

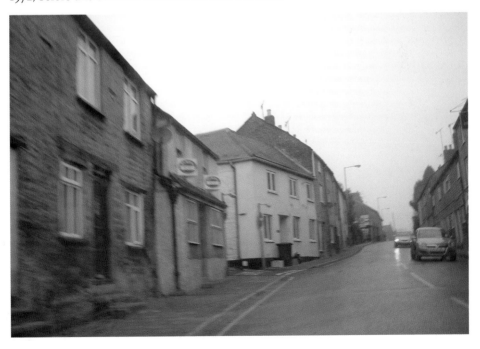

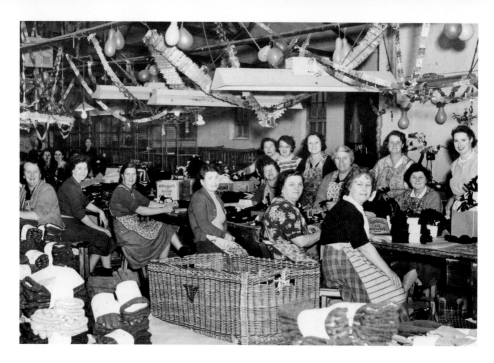

Southcombe Brothers, Shirt Manufactures, 1906

By 1939 the West Somerset Shirt Factory in Abbey Street had taken over the business belonging to the Southcombe Brothers. In 1953 the West Somerset Shirt Factory was replaced by Bonsoir, which later closed in 2006. Today, the premises is now comprised of luxury apartments. The above view shows the factory workers making gloves in the 1960s.

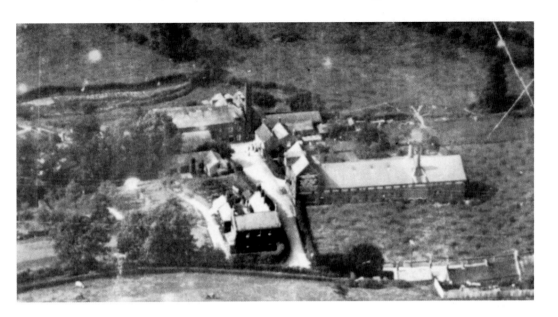

Malthouse, 1883

The long building pictured above was the malthouse, which belonged to Crewkerne United Breweries. In 1925 the celebrated beer was Pale Ale, and stout was produced in casks or bottles. The brewery closed in the late 1930s. Over the years it has been owned by many companies, including Isaac, beer and grocery wholesaler, in the 1960s. In 2011 it was transformed into houses and flats.

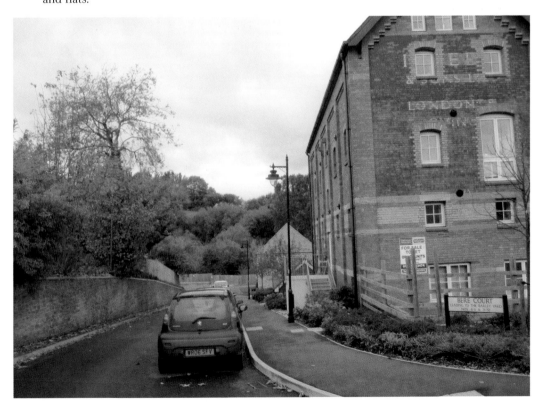

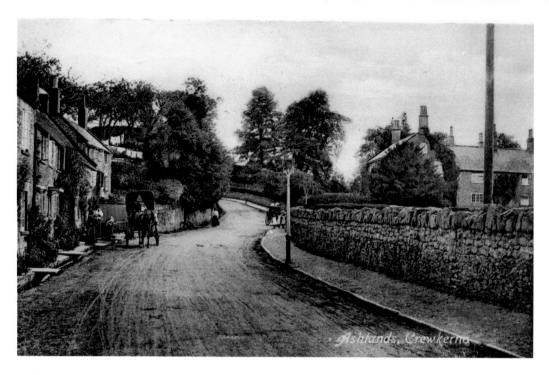

Ashlands, 1800

Once a turnpike road, this is now the location of the main road from Crewkerne to the A303, and onward to London. Crewkerne Dental Centre is situated where the traffic lights are; also on this site is Girling & Bowditch, veterinary surgeons.

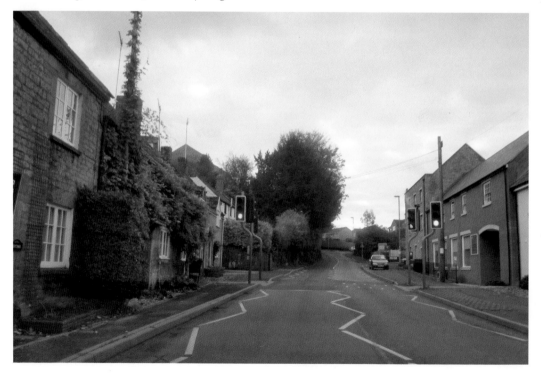

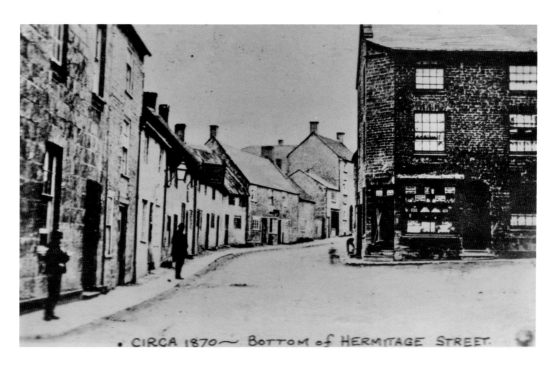

· CIRCA 1870 ~ BOTTOM of HERMITAGE STREET.

The White Lion, 1870

This photograph of the bottom of Hermitage Street looks up towards the White Lion Inn, which can be seen on the left. A decade later, in the 1980s, it became the White Lion restaurant. W. Cooksley, family butcher's shop, moved to this area in 1925; they owned a slaughterhouse on Chard Road, just out of town. In 2011 it became Inkwell custom tattoo studio.

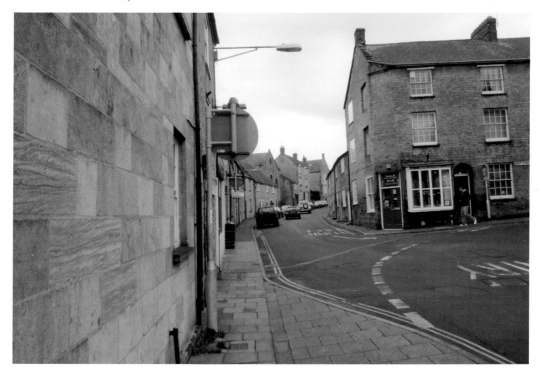

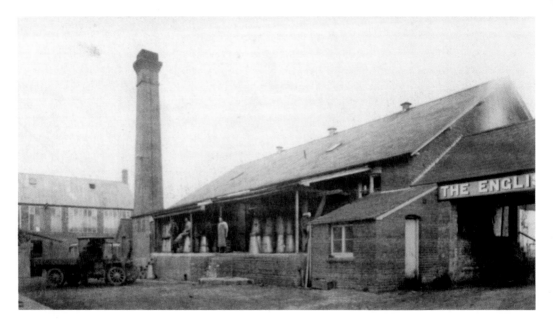

The English Dairy

Once named Parrett & Axe Vale Dairy, in 1914 it was renamed The English Dairy. The dairy was located on Hermitage Street and closed in the 1960s. Farmers then took their milk to the dairy in Watercombe, Yeovil. In 1962 Stirling Industries had an office block here. Sometime after 1970 D-ac were based here, before becoming Varta Batteries. They then relocated to Blacknell Lane and eventually closed in 2003.

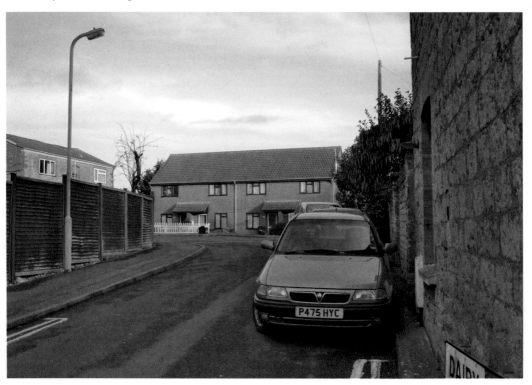

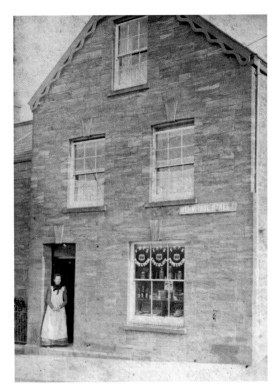

Hermitage Street

Hannah Pattemore stands in the doorway of her shop on Hermitage Street in 1906. In 1935 the shop was listed as a grocer's, owned by E. Foot, and around fifty years later in 1980 it was owned by Margaret and Ricky Doberstein before closing in the 1990s. It became a private dwelling in 2004.

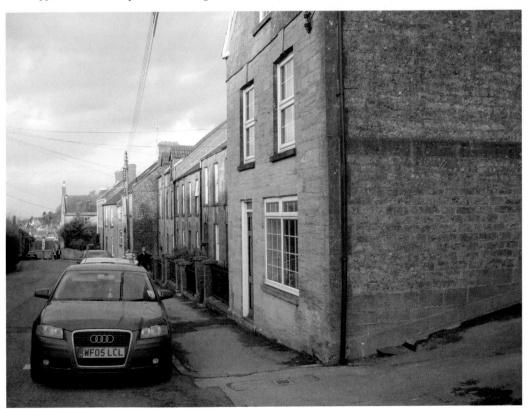

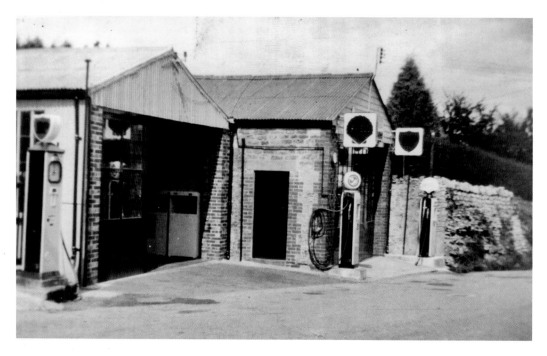

Pennel King, Lyme Road

In 1935 Pennell King, motor engineer, was situated on Lyme Road. In those days the pumps were turned by hand. The garage had links with Humber, Hillman, Morris and Austin cars. In the 1970s Edward (Ted) took over and the garage was renamed Kings Court. This closed in 2008. Housing now stands in its place.

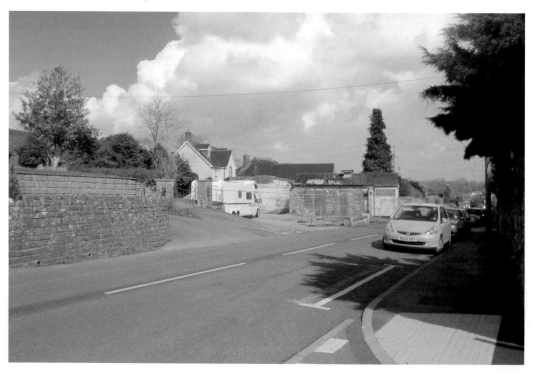

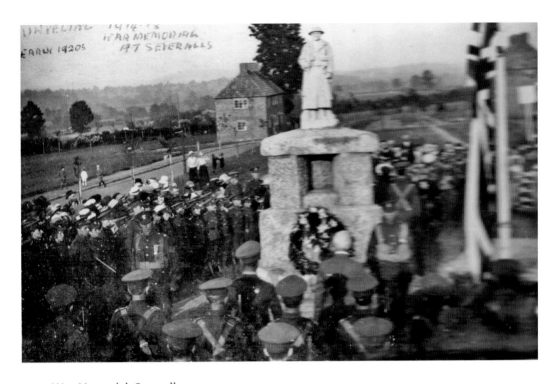

War Memorial, Severalls

Exactly 127 trees were planted here, one for each of the fallen from the First World War, and the war memorial commemorates those fallen from Second World War and other wars since. Severalls was one of the first council sites to be built in the country after the Second World War.

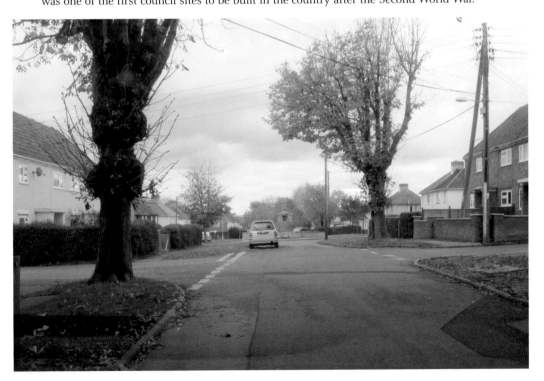

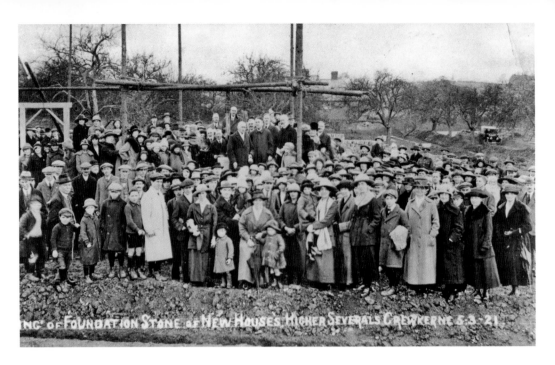

Higher Severalls, at the Start of Blake Road, 1921
The orchard pictured in the photograph belonged the Budge family in the 1940s. Len Newbery's slaughterhouse was here, and this was also where William (Bill) Pattemore started his milk churn and haulage business. In 1985 Geoff and Steve Pattemore moved to Mosterton Road, and began delivering milk from 4-pint bottles to bulk deliveries. Below is a view of Blake Road in 2012.

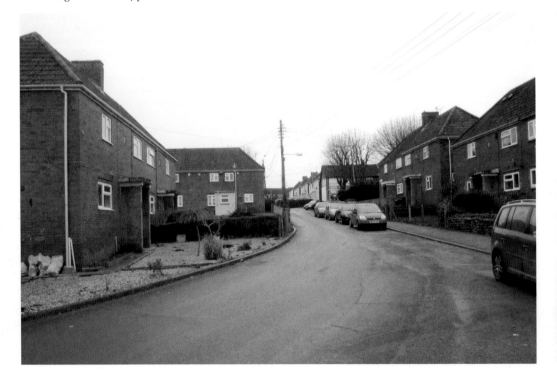

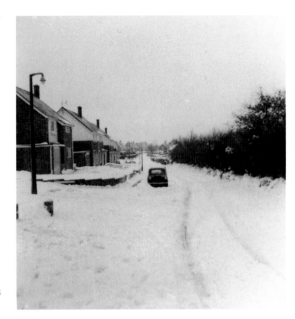

Lang Road in the Winter

Pictured to the right is Lang Road in the winter of 1962/63. In the 1960s, Bushfield estate was built here, and not long after, in 1968, Park Lane estate was also constructed.

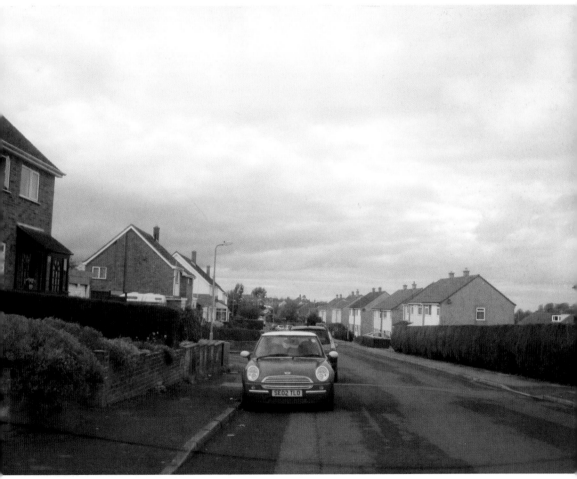

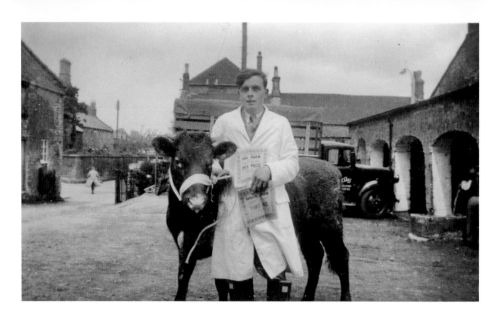

Crewkerne Farmers' Market

Crewkerne Farmers' Market opened in the 1940s. It was held outside the Victoria Hall, before being moved to the area that is now West Street car park. Pictured is Tony Pardy with a cow. The building on the left was the infants' school, which was erected in 1847. It was converted to West One Youth & Community Centre, and there are plans to convert the building into a doctors' surgery in 2014.

Cattle Market

Crewkerne Annual Fair cattle market closed in 1951. The area is now West Street car park (where the sheep pens were, on the right), and to the left of the old photograph is now West Street Bowls Club.

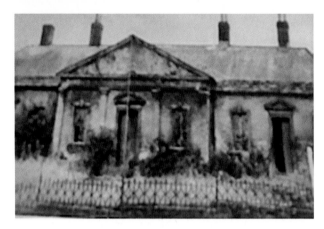

Almshouses

In 1707, Miss Mary Davis founded and endowed an almshouse in West Street for six poor old men and six poor old women, who were once housekeepers, belonging to the town of Crewkerne. It was demolished in the 1960s and Chubbs Lawn housing area was later built on the site.

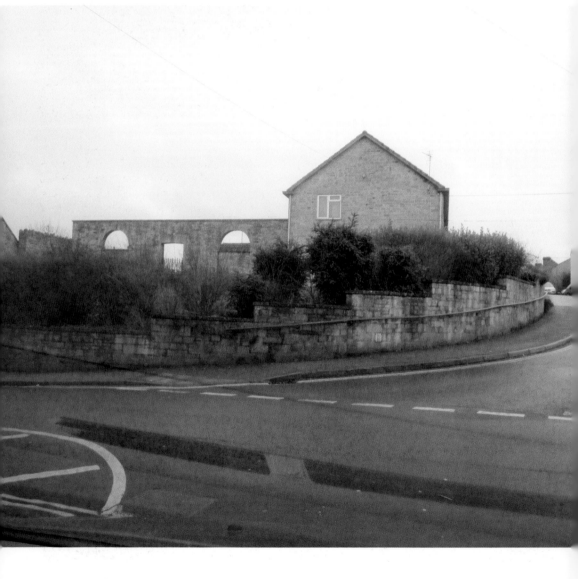

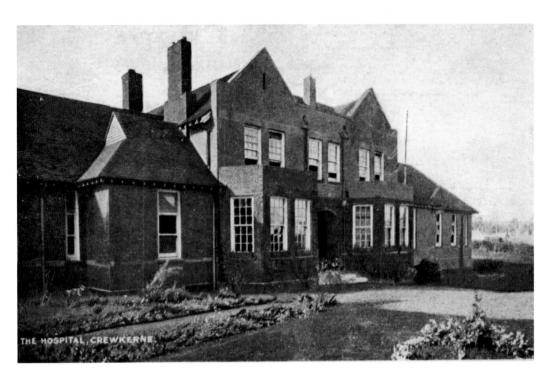

The Hospital, Crewkerne

Crewkerne Hospital

The hospital was founded in 1867 by Robert Bird. It later moved from South Street and was rebuilt on this site in 1904. The men's ward was on the right, the women's ward to the left and children were accommodated upstairs. Operations were carried out here in years gone past. Nowadays Crewkerne Community Hospital provides twenty in-patient beds, with the support of the League of Friends.

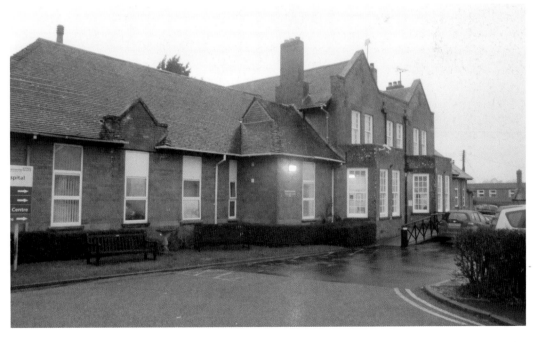

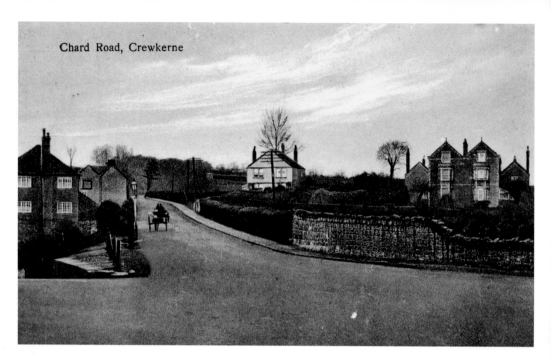

Chard Road, Crewkerne

Chard Road

In 1840 the road straight ahead was the new bypass to Exeter, and before that the road went to the left into Lyewater and then up Hewish Lane, coming out at Roundham. The Cross Keys used to face the other way in those years, and then they turned it around to face the new road. The house facing this was Mr Arnold's grocer's shop in the 1930s, and next on was Roy Hodges' steam baker, which moved to the Square in 1928.

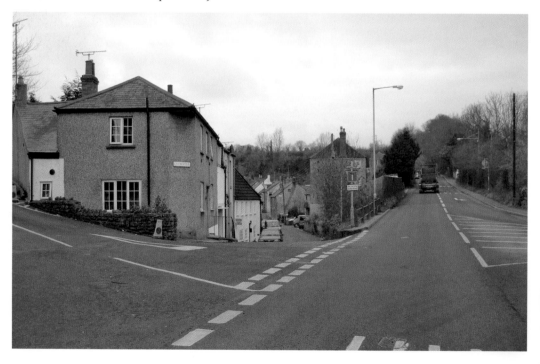

St Raynes Hill
In 1932 the lorry belonging to
Mr Fred Stagg, farmer, crashed on the A30
on St Raynes Hill, leaving one man dead.
This is a very dangerous corner, which has
seen a number of crashes over the years.

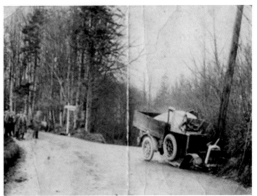

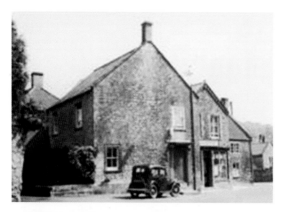

John Stoodley's Butcher's
In 1906, John Stoodley had a butcher's shop in Court Barton. Down the road, on the right, was Crewkerne fire station. In 1948, Vic Dening took over as butcher, and in 1960 Brian Dening became the owner. The shop closed in 1978. In 2000 the shop was converted into a flooring business, and six years later it became housing.

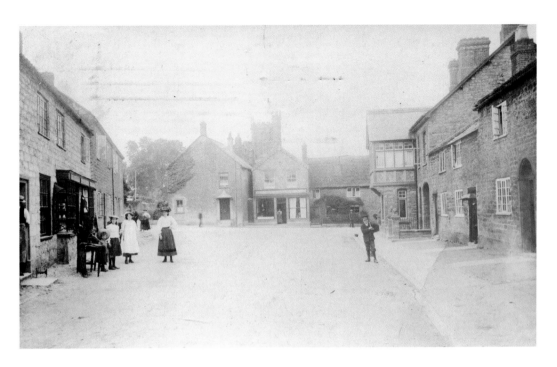

William Pavy Baker's

In 1861, William Pavy had a bakery in Court Barton. Forty-two years later, on 25 May 1903, Ralph Reader CBE was born in this house. He went on to become the creator of the Royal Air Force Gang Shows. In 1950 Fred Osborne's garage was situated on the right, and in 2012 this area became home to Little Nippers Nursery.

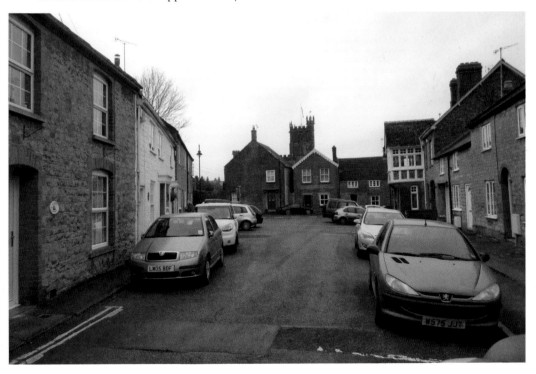

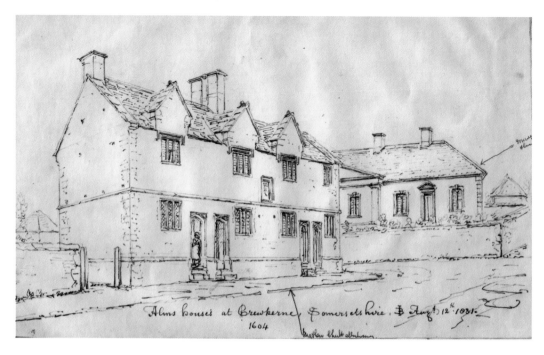

Alms houses at Crewkerne, Somersetshire. Aug 12ᵗʰ 1031.
1604

Chubb's Almshouses, 1906

These almshouses were founded by Mathew and Margaret Chubb, 'for the perpetual relief of eight poor people who should be inhabitants of the town of Crewkerne and Misterton'. The adjoining almshouses in West Street were built in a similar Jacobean style in 1897. The modern image shows the almshouses today, looking to Middle Path, which in 1800 was called Gas Lane.

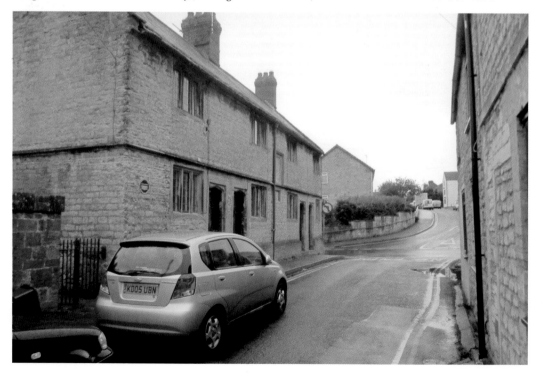

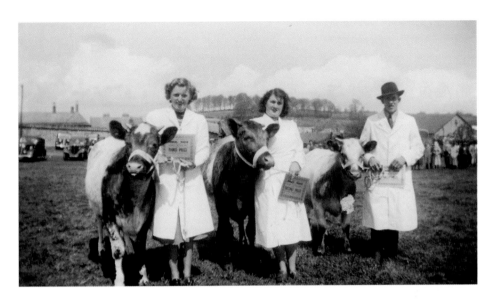

Chubb's Lawn, Middle Path, 1940s

Pictured are members of Crewkerne Young Farmers: Mrs June Creed, *née* Rendall, Mrs Ann White *née* Thomas, and the late Graham Crimpler. This field was also used for the Bernard Hill fun fair and circuses in the 1940s and '50s.

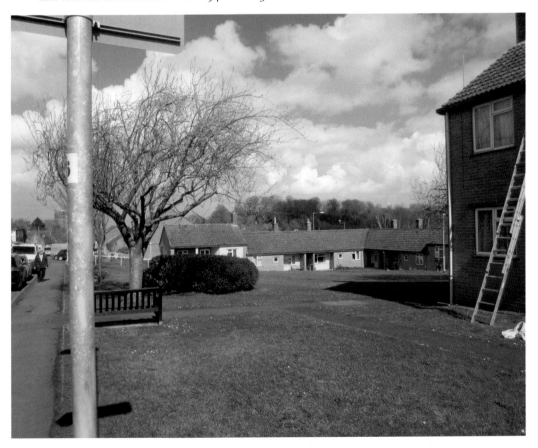

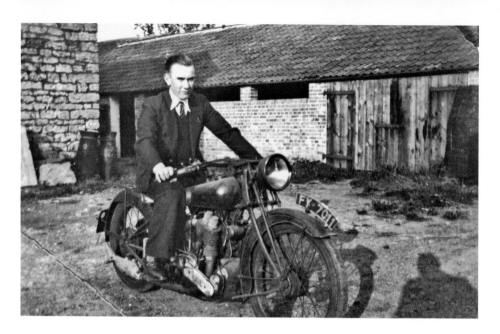

Elms Farm, South Street

Dating from 1600, Elms Farm is one of the oldest properties in the town. In 1930 Fred Stagg owned the farm; the cows were milked in the building seen on the right. Fred's son Leonard, seen above, carried on the milk business, collecting the milk churns from the farms in area and taking it to English Dairy in Hermitage Street, and later to the dairy in Beaminster.

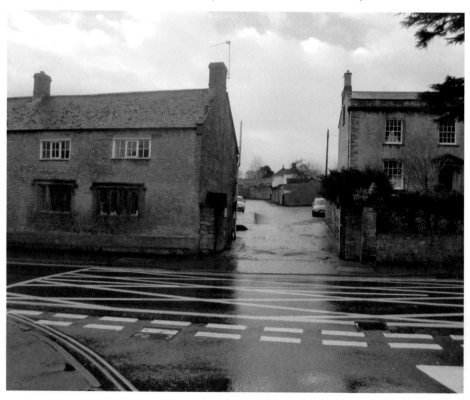

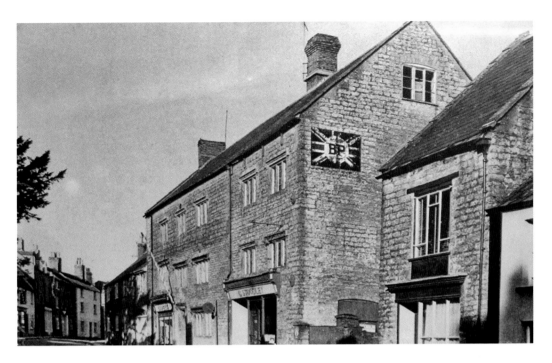

Development

In 1973, three shops and six almshouses were demolished to allow for road widening, the construction of new car park and the entrance to the new Falkland Square complex. Crewkerne Day Centre was built in 1974. However, this was knocked down in 2008 to make way for the new Waitrose store, which opened 13 November 2008. The houses seen on the right are Bryants Row, built in 2006.

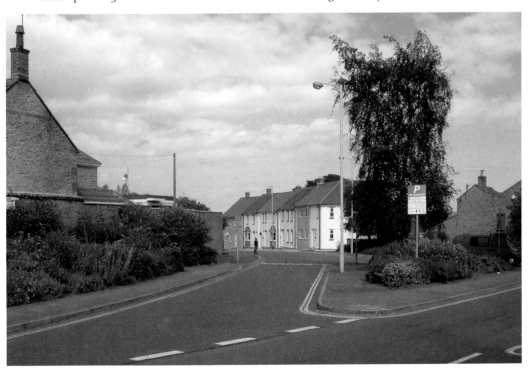

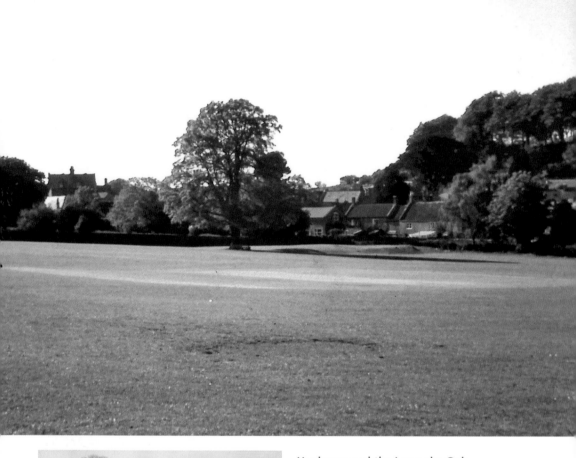

Henhayes and the Lucombe Oak
Henhayes field as it was in 1950s. Visible is
the Lucombe Oak, which is over 150 years
old. Beyond were the St Martin's school
playing fields. The Aqua Centre opened in
1998, and the Fitness Centre was opened in
2002 by Princess Anne, while the George
Reynolds Centre opened in 2012.

Bryant's Bakery

In 1927 Winfred Bryant came to Crewkerne, the first of three generations of the Bryants to live here. Donald Bryant took over the business in 1948 after his father died, and David Bryant became a partner in 1995. Donald lived to the age of ninety and was still working up until the day he died. The bakery was behind the shop in the early years, but moved in the 1950s to the former site of the Barrett slaughterhouse. The shop later moved next door to the bakery, but finally closed in March 2004.

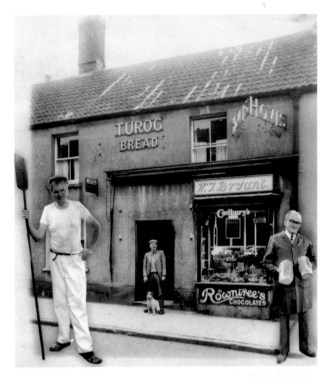

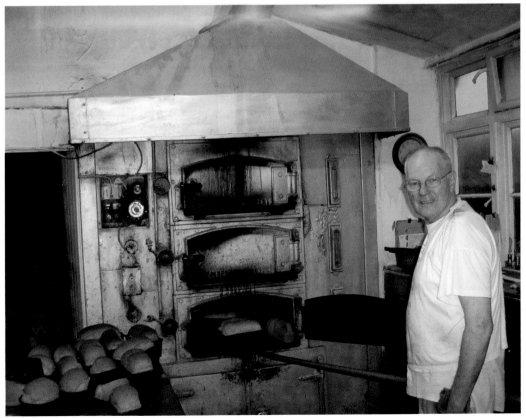

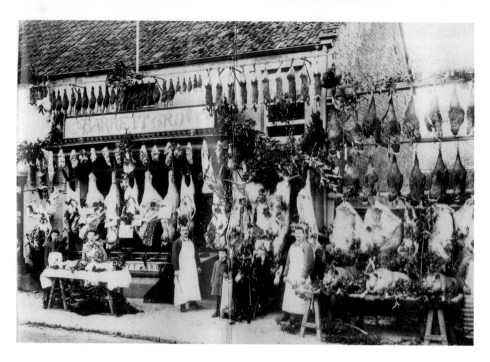

Barrett's Butchers

This 1906 image shows the Barrett butcher shop. The slaughterhouse was behind, which later became Bryant's bakery. In 1932 the butcher's became Perrott's dispensing chemist, and by 1940 was Mrs Hurd's chemist's. Within twenty years it would become Bryant & Son's bakery shop. In 2006 AF-IT computer services took over the premises.

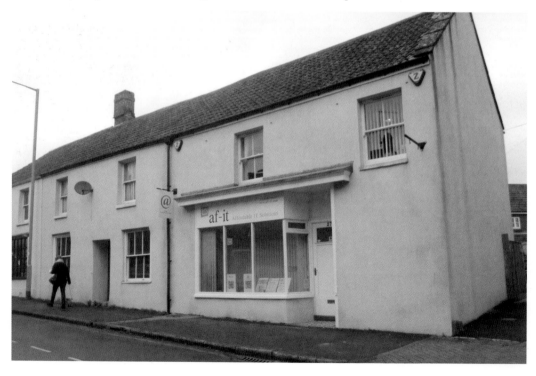

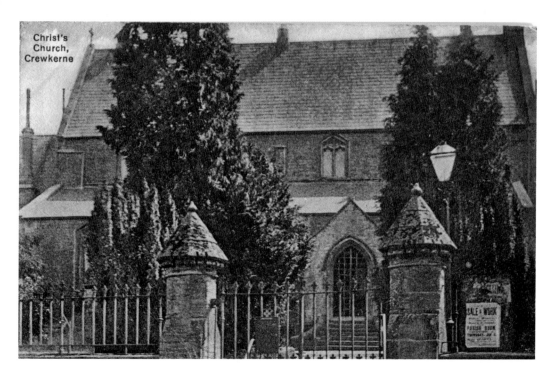

Christ's Church, Crewkerne

Christchurch

In 1854, Christchurch was erected in South Street as a chapel of ease. It was served by the clergy from St Bartholomew's church. It was a stone building in the Perpendicular style, consisting of a chancel and nave of four bays, one bell and stained-glass windows that were erected in 1886. Demolished in 1976, the original stone can be seen in the walls around Christchurch Court.

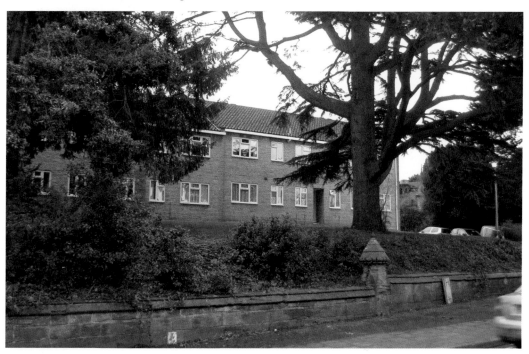

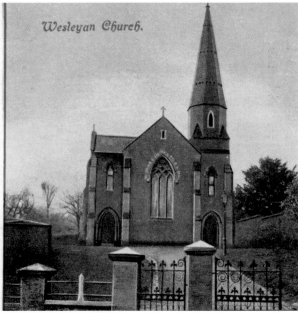

Methodist Buildings

The town's Wesleyan chapel was built in 1834; it is seen here in this postcard by Quick & Taylor of Market Street, dating from 1906. The modern Methodist church was constructed in 1970, and is now shared with the Roman Catholic congregation. The nursery school can be seen on the left.

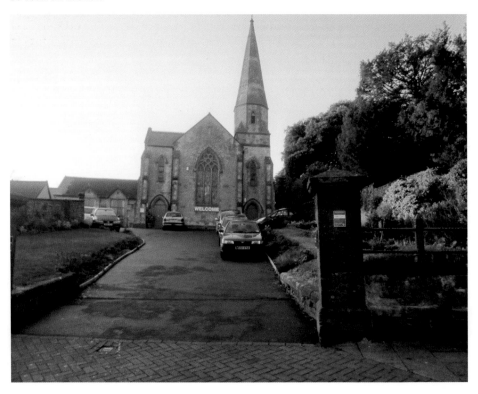

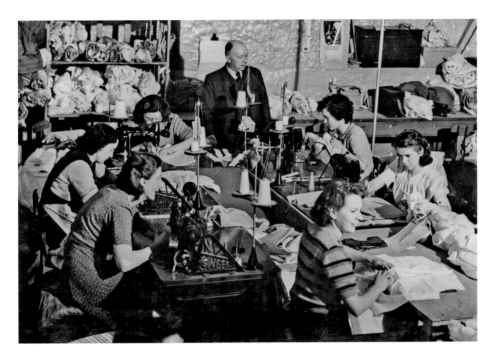

Robert Bird & Co., Linen & Woollen Web Manufacturers

In 1876, Robert Bird established a trust for the benefit of old weavers employed in his factory, providing six cottages in South Street and a capital sum of £1,080 for their maintenance. They were demolished in 1973 and replaced by five bungalows. In 1938, Haslock's webbing factory closed. In 1945, the Standard Light Company closed. The Van Heusen shirt factory, which had started above the Standard Light Company's machine shop in 1951, closed in 1978 and moved production to Taunton. The premises then became Chalmers & Co. and the Lawrence Sale Room.

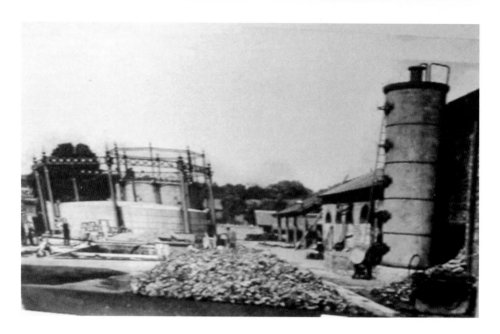

Crewkerne Gas and Coke Works

The gas and coke works opened in 1861 under the management of a Mr J. Nicholls, who claimed 'domestic drudgery is unknown if gas is used throughout the home'. The old-fashioned gas ohmmeters of this period were finally taken down in 1980s, and Singleton Engineering is now based on the site. The visible building is Dr Osborne's surgery.

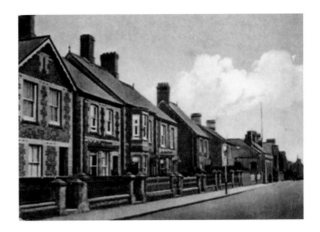

Portsmouth Villa

These houses were built by Mr Lye in
1901. In 1938 No. 141 was known as
Portsmouth Villa. At this time there
was no entrance to Blacknell Lane;
the railings went all the way down to
Frank Parsons' printer's.

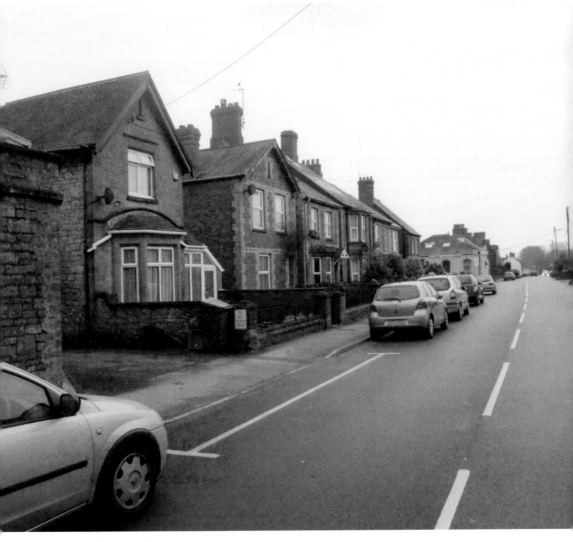

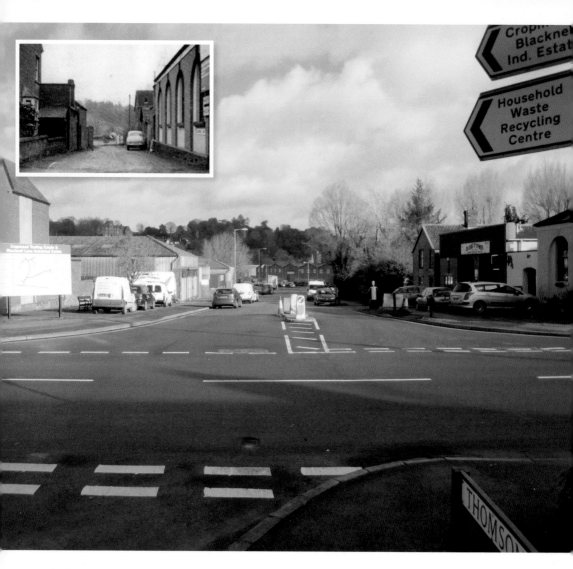

Blacknell Lane

The inset photograph shows Blacknell Lane in 1950. Charlie Rome's printer's can be seen on the right. In 1963 the house on the left was knocked down so that the road could be widened for the Blacknell Lane industrial road. In 1989 the printer's became a restaurant, run by Maurice and Mary Chown. In 2000, it became Ip's Palace Chinese restaurant.

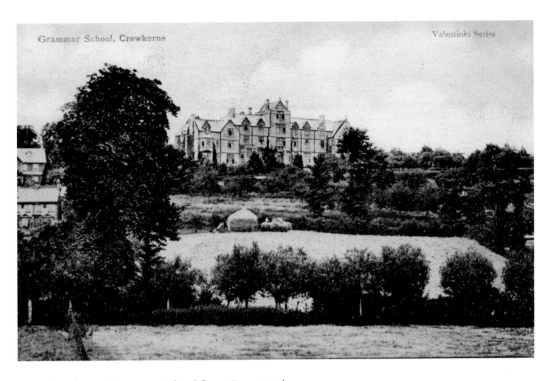

Crewkerne Grammar School from Cropmead

The Grammar School in Abbey Street closed in 1904. The following year the new school opened at Mount Pleasant, East Street, but this was to close in 1972. A new school, Wadam Community School, was built at Wadham Park, opened in September 1971. Children from the Crewkerne and Ilminster areas attend. The modern photograph shows the Cropmead industrial estate.

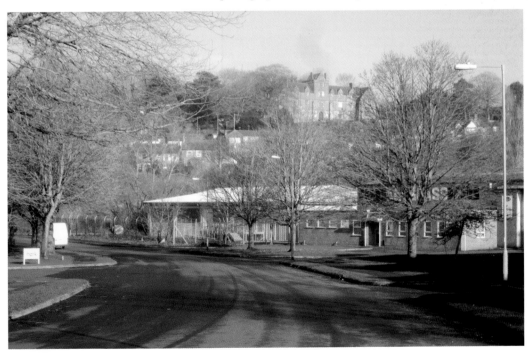

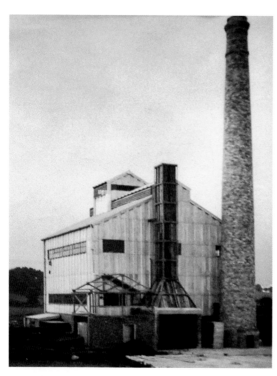

Crewkerne Incinerator
This 1940s image shows the Crewkerne incinerator. The dustcart, driven by Walter Fone, would go around the town and collect all rubbish, and then it was the job of stoker Fred Lawrence to burn all household waste in the incinerator. By 2000 this was the site of the recycling depot, Froom's coal yard and Hallett metals.

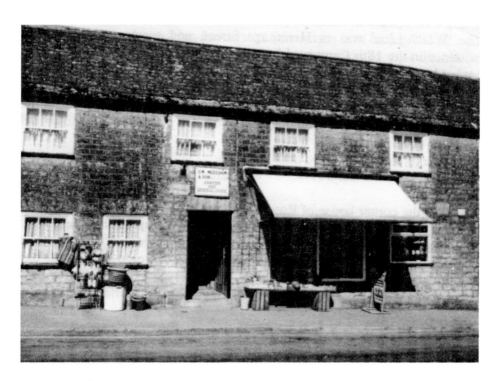

George Meecham & Son

In 1931 this was the premises of George Meecham & Son, sellers of groceries and household items. The modern image shows that the shop has now been turned into houses. As his son Brian also did in later years, George would take his van out to deliver to people in the surrounding villages. The shop closed November 1998. Meecham & Sons is thought to have been the model for the shop in the television series *Open All Hours*, starring Ronnie Barker. Sadly Brian passed away in 2012.

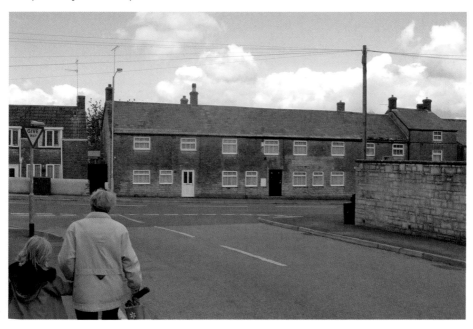

Happy Valley

Another image from 1940, this time showing Pat Masters with her doll's pram in Happy Valley, which was up Shute Lake Lane. On 1 July 1994, St Bartholomew's School was opened here by Bishop Jim Thompson of the Diocese of Bath and Wells.

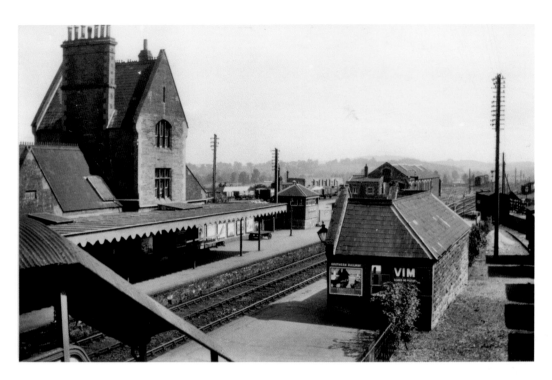

Crewkerne Station

Crewkerne station was opened in July 1860, when the London & South Western Railway opened its Yeovil to Exeter Railway. In 1948, the train *Crewkerne* 34040 was unveiled by the chairman of the council, L. Dealey. In 1953 an accident occurred when the axle bogie came off the train and brought the canopy down when passing though the station. Today there is just a single track for South West Trains services on the Waterloo to Penzance route.

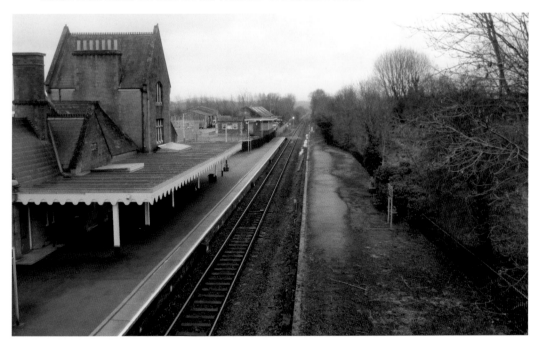

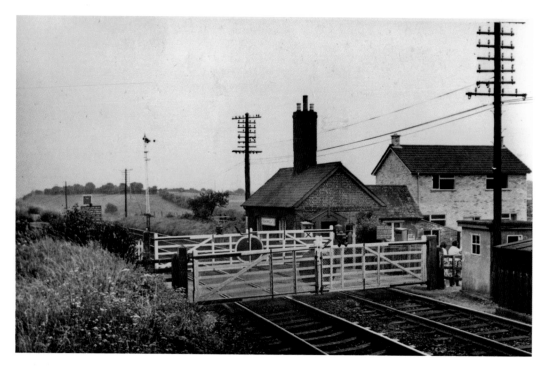

Crewkerne Gates

This 1948 image shows the Crewkerne gates; Alfie Wrigglar was the gatemaster. In the late 1950s, Burt Elswood and his wife brought their family up in this small house next to the railway. It was knocked down in the late 1960s and the new railway house was built.

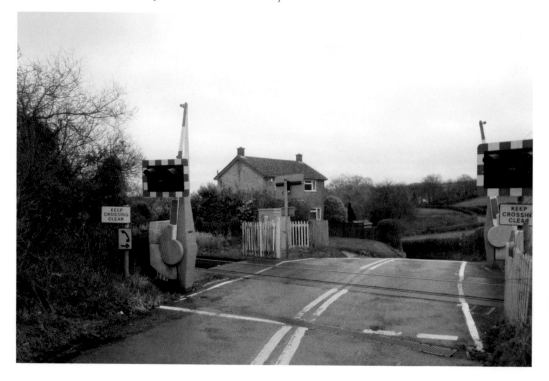

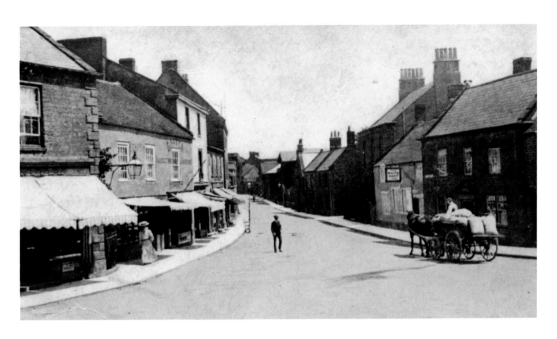

East Street

The Dunster bakery shop is on the left with Bashford's shoe shop. The Midland Bank building, dating from 1940, is also visible; in 1999 it became HSBC. The third building on the right is the White Hart Inn. Previously known as the George, it is the oldest of Crewkerne's pubs. Its striking windows and fireplace are believed to date from around 1500.

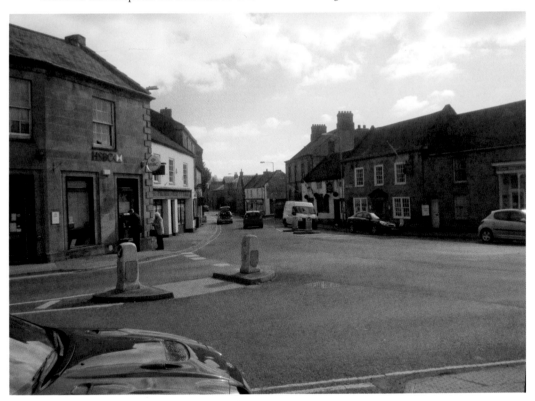

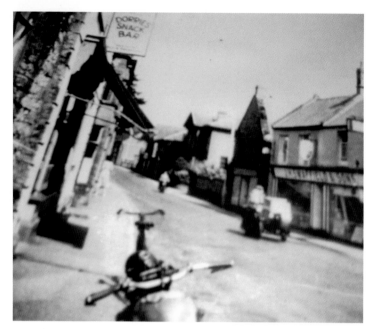

Candle Cottage

In another image dating from 1948, Dorries snack bar is seen, with Tom Swaffield's garage on right next to Hallett's grocer shop, which closed in 1951. This was previously part of Candle Cottage, where Fredrick Stringfellow lived – the brother of the famous aviator from Chard, John Stringfellow. In 2013 a new gas main is being installed.

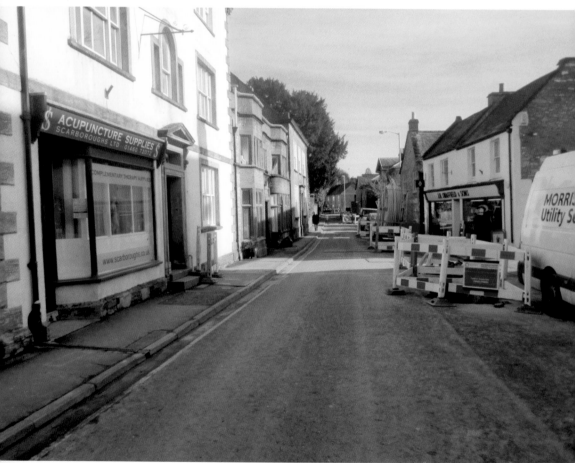

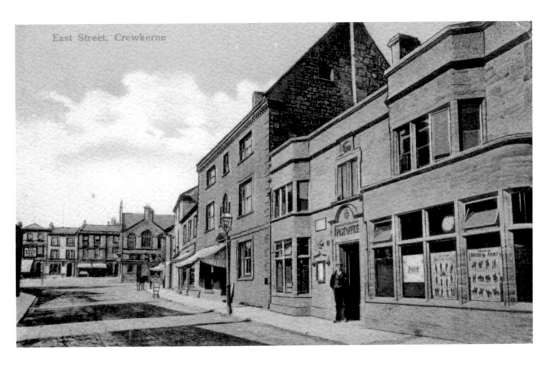

East Street, Crewkerne

Crewkerne Post Office, East Street, 1872
The postmaster at this time was John Budge. The post office moved to Market Street in the 1930s, but moved back to East Street in 2000, taking premises two doors up from its old site. The modern image is a shot from the 2009 Tour of Britain cycle race.

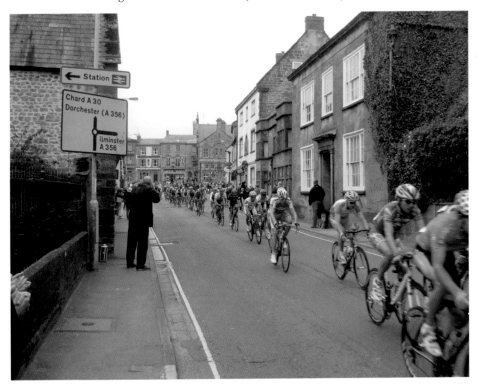

Merefield House

This imposing building was the townhouse of the Merefield family. The oldest part of the dates from 1589; however, the main fabric of the existing structure was built 1810–11, and has been described as 'a fine example of Regency architecture'. Opposite, the commercial premises was E. A. Taylor's motorcycle shop in the 1950s, Bernard Singleton car sales in the 1970s and, by 2005, Country Too Antiques.

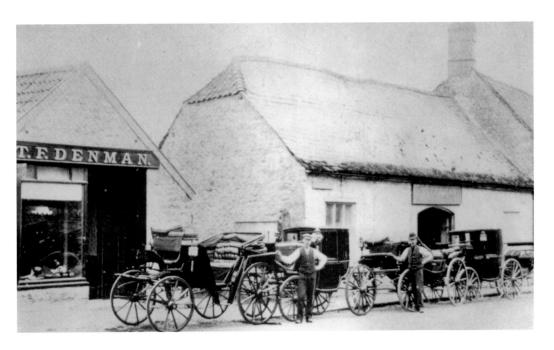

T. F. Denman

In the census of 1861, Tom Denman was described as a coach builder from Fancourt East Street. After T. F. Denman closed, it became Miller's garage for many years. Millers garage closed in the '90s. It was sold and became Anglo Court as we know it today.

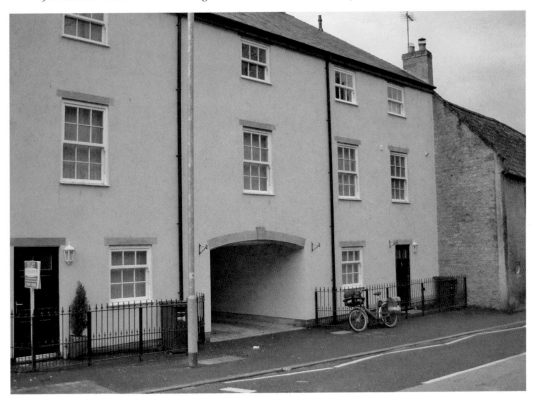

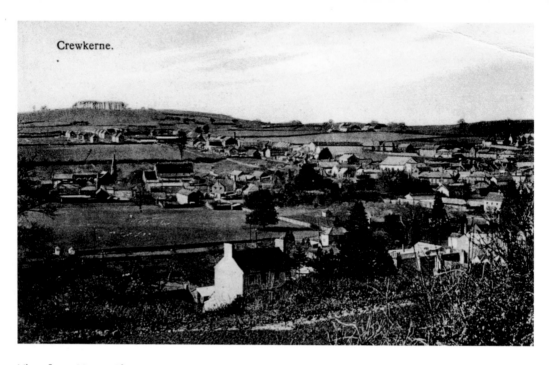

Crewkerne.

View from Mount Pleasant

This striking 1928 view shows Henhayes field with the Lucombe Oak and the start of Higher Severalls estate. It is paired with a 2011 view of De Coombe House, Mount Pleasant, which was formerly the grammar school until its closure in 1972.

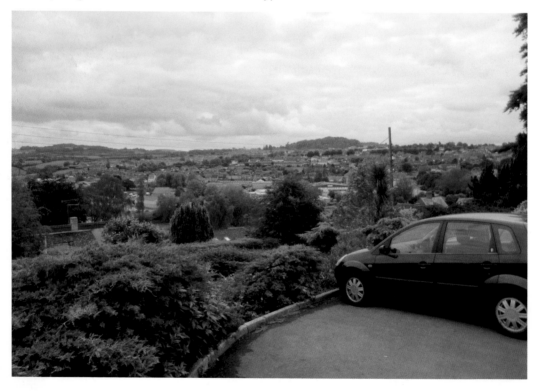

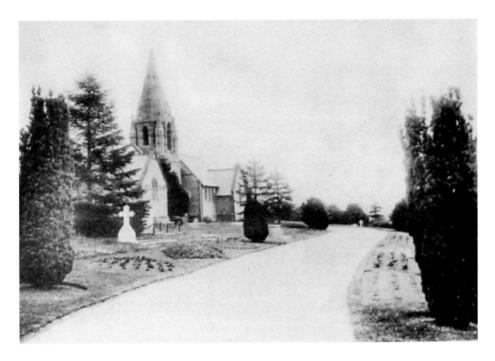

Journeys End

This photograph shows the 1876 Townsend Cemetery. Not a lot has changed here; it has just got bigger with the addition of a lower part for cremations and burials.

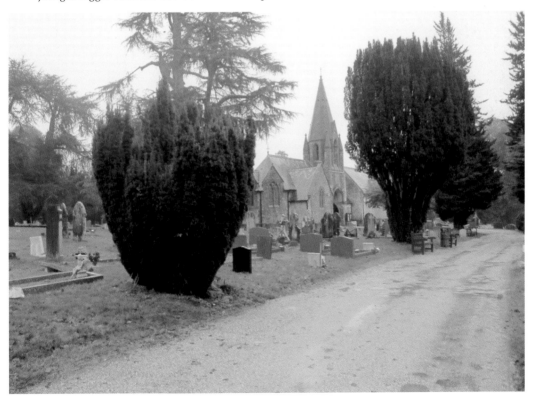